MICROWORLDS

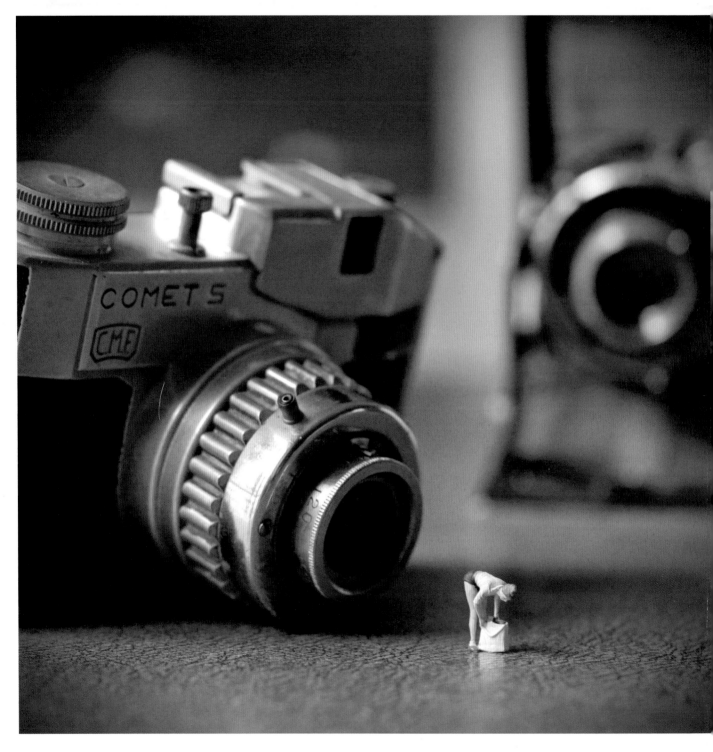

MICROWORLDS

~

MARC VALLI &
MARGHERITA DESSANAY

AN ELEPHANT BOOK

LAURENCE KING PUBLISHING

Published in 2011
by Laurence King
Publishing Ltd
361–373 City Road
London EC1V 1LR
United Kingdom
Tel: + 44 20 7841 6900
Fax: + 44 20 7841 6910
email: enquiries@
laurenceking.com
www.laurenceking.com

This book was
designed and produced
by Laurence King
Publishing Ltd, London

A catalogue record for
this book is available
from the British Library.

ISBN: 978 1 85669 787 3

Design by Cai and Kyn

Printed in China

Page 2: Comet's
Peeping Tom
by Vincent Bousserez,
digital photograph

This page: To See Gold
by Liliana Porter,
mixed media

Page 142: Reading,
waiting for the rain
by Vincent Bousserez,
lambda print

GROWING CONCERNS IN AN EVER-SHRINKING WORLD

~

BY MARC VALLI

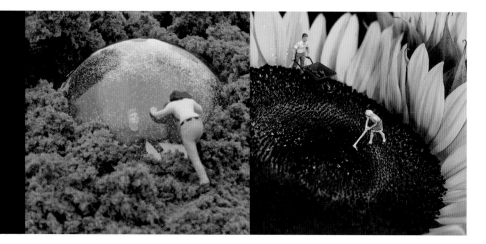

The Eiffel Tower went up in just two years, in time for the Universal Exhibition of 1889. This steel structure designed by an engineer became an emblem for the new mechanized age. It would inspire countless modernist artists and continue to be the tallest building in the world until the erection of the Chrysler Building in 1930, soon to be dislodged by the Empire State Building and the Twin Towers in 1972.

Faced with the multiplication of such giant structures (skyscrapers, stadiums, flyovers, housing projects, dams, airports, etc.) one experienced contradictory impulses. One felt both god and ant-like, and this complex sense of being out-of-scale is expressed in the work of numerous twentieth-century artists, from Claes Oldenburg, Robert Smithson, Walter de Maria, Christo & Jeanne-Claude and Jean Tinguely up to, more recently, Antony Gormley, Damien Hirst and Tristin Lowe. Despite being very diverse in nature and style, they all have something in common: size. The world had grown too big for us human mortals and the colossal scale of these works expresses a sense of awe and puzzlement.

By the turn of the century, however, these feelings had started to change. 2001 was the year Google turned its first profits and the Twin Towers were flattened (by a militant network communicating digitally and able to handle jets' complex software systems). We had entered a new period, leaving the era of mechanization behind (no more Twin Towers in the New York skyline) and heading full download speed (and not steam) into a new revolution: the Information Age.

More than a new age, we had entered a different dimension. We were turning away from our bay windows to look at screens as one would put down a pair of binoculars to bend over a microscope. We no longer gaped at gigantic structures, but wondered at the infinite possibilities of artificial intelligence, virtual worlds and communication highways. Interestingly, nowadays, every

'We no longer gaped at gigantic structures, but wondered at the infinite possibilities of artificial intelligence, virtual worlds and communication highways.'

Hollywood movie features at least one character frowning intensely at a screen. Clearly, this is where all the action is taking place.

The internet is the greatest microscope of all. But determining scale and context is no simple matter when you are looking down such a powerful amplifying tool. Unless you were a scientist used to analysing data and equating this varied input with reality, travelling through the internet was a vastly new experience. As we surf, the world flows around us. We can see it with an unprecedented wealth of detail, but we cannot seize it. This new reality is made out of millions of atoms, of disparate figures, objects, opinions, theories, stimuli – most of it highly unreliable. There are no set parameters: serious, unserious,

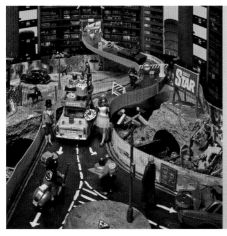
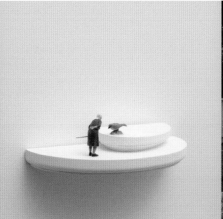
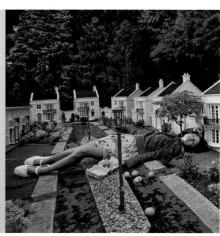

high, low, big, small, galaxies, leaves, buttons, historical figures and football scores… – all bathe in the same soup.

Today, we are no longer dwarfed by great structures such as the Eiffel Tower or the Empire State Building, but submerged, immersed, in a sea, a substratum of information and stimulation. The world of the Universal Exhibition of 1889 (with its sense of monumental fun and inevitable progress) has been transformed into the chaos of this immense and unruly play room, this turbulent wonderland. The Eiffel Tower is among us still. You don't even need to go to Paris. You can get it off eBay. Sizes and prices vary.

The work of the artists in this book expresses this new sense of being in the world – in a new world, an unsettled and unsettling world, a world in which everything keeps changing at ever-increasing speeds. In Etienne Clément's works, people rush through ruined dystopias, in which buildings and motorways seem always in the process of being built,

demolished, re-built, while historical periods merge and tabloid headlines (referencing, for example, Marie Antoinette's infamous and, incidentally, fictive quote) pop-up everywhere: '"Eat Cake!" Says Queen'.

This new situation, this new vantage point (in many ways closer to that of the medieval than the enlightenment one) was bound to have an effect on how artists dealt with what is around them. For example, when faced with an unprecedented construction boom on her return to Beijing ('no area was left unchanged'), Chinese artist Danwen Xing didn't set out to build colossal works of her own, but turned her attention instead to real-estate agents' maquettes, creating new

'Human beings have never travelled so much, nor so fast, both physically and imaginatively, and miniaturization mirrors this transience.'

in-between 'worlds, not quite virtual, not quite real, parallel worlds trapped somewhere between dream and reality'.

Human beings have never travelled so much, nor so fast, both physically and imaginatively, and miniaturization mirrors this transience. The migrant is a recurrent subject in Liliana Porter's work: a small, nameless nomad lost in vague and equally nameless spaces trying to find his or her way home. This home is nowhere to be seen. The concept of home itself is no longer what it used to be. Danwen Xing's characters inhabit a real-estate limbo not so far removed from that of the employees of large corporations, constantly travelling for work, hopping between furnished flats in foreign cities. Suitcase in hand, one of Thomas Doyle's characters comes back to his home inside a glass dome, only to find it blown to pieces. Even the nostalgic, pre-war universe of Paolo Ventura's *Winter Stories* is full of change and movement. People put their heads through trompe-l'oeil backdrops representing the latest technological invention (a two-seater ▶

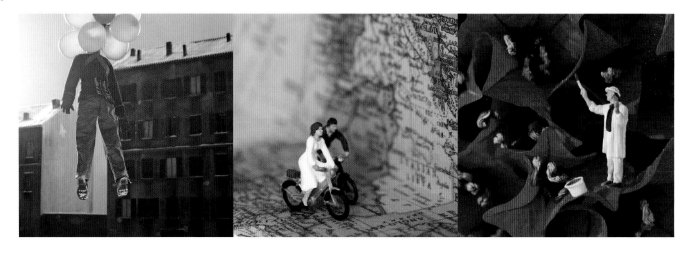

aeroplane) to pose for photographs. Posters and ads are carefully reproduced in the background, alluding, in rather post-modern fashion, to the presence of worlds within worlds. Circuses and itinerant artists pass through the town. A man is carried into the air by a bunch of colourful balloons.

Naturally, as a lot of the miniatures and props used by the artists in this book have come from model kits, vehicles (cars, trains, ambulances, trucks, tractors, planes) abound. But the imagination is still the miniaturist's favourite mode of transportation. Their characters rock-climb over buttocks and ice-skate over cocaine-strewn mirrors. At rush hour, one of them may decide to take a lift on the back of a slug, while impatient advertisers put up wall-sized polaroid posters on the side of the road. At the weekends, they may choose to mow stubble or shoot down bumblebees or paint butterfly wings.

These vertiginous shifts in scale allow us to travel not just in space, but in time. We regain the world (and the viewpoint, the perspective) of our childhood, when the world was filled with toys and figurines enacting complex and imaginative scenarios. We were closer to the small things around us then, and miniaturized works reproduce this alertness, this playful fascination with the world's infinite possibilities. A drainage pipe becomes a mysterious tunnel, a ledge grows into a vertiginous cliff, a mushroom blossoms into a parasol while a lid sails across an oceanic puddle. Lisa Swerling describes how, while playing, her daughters are able to effortlessly turn ordinary objects into magical ones simply by changing their context. In her work, the artist tries to experience the world as they do, and to build worlds that reflect this ingenuity.

This innocence, these fresh and unmediated encounters with the world have become precious commodities in the Information Age. Graeme Webb remembers playing as a child in bomb-damaged areas of London in the late fifties. Santiago Lorenzo believes the impulse behind his work with miniatures stems from not having been allowed to play with them as a child. After finishing a piece, he can't resist bombarding it with marbles and firecrackers. Paolo Ventura tries to recapture those moments of childhood boredom (those friendless, rainy Sunday mornings) when he would look around and start inventing games and stories and characters. In the age of computerized gaming, boredom should also be listed as an endangered commodity.

'These vertiginous shifts in scale allow us to travel not just in space, but in time.'

But idylls (even digital idylls) are usually short-lived, and reality, and often violent reality, is always around the corner (or behind a fence, or a couple of blocks down the road). Sicilian artist Adalberto Abbate remembers first thinking about miniaturization after witnessing a fight from his window.

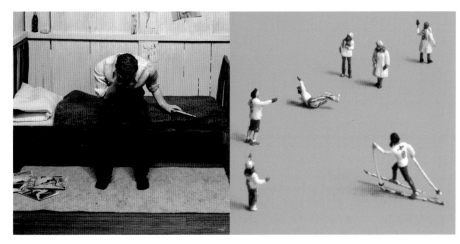

His distinctly toy-like artworks are filled with a violence that is difficult to dissociate from that of the socio-political reality of his native mafia-plagued Palermo. Corinne May Botz based her works on those of criminologist Frances Glessner Lee (1878–1962), who reconstructed miniaturized crime scenes of real-life homicides, suicides and accidental deaths for the purpose of training detectives. Crime, prostitution, perversion and porn populate the (under)worlds created by Jonah Samson, a doctor whose work (in real life) involves people with addiction and psychiatric problems. As a doctor, he is naturally reticent when it comes to talking about his day job, and one can only speculate on the connection between the fragility of his noirish dioramas (one is tempted to talk about 'diodramas') and that of his real-life patients.

Miniaturization is a surprisingly effective strategy, drawing the viewer in, as Gregory Euclide points out, not just imaginatively, as a picture would do, but also physically. As children, we were acutely aware of this. And of how this in turn induces a sense of heightened awareness, and heightened wariness. Small things are fragile things and miniaturized worlds exist in a precarious equilibrium. The wind could blow everything away, or someone (an adult, usually) could accidentally step on it. Thomas Doyle points out that there is a strange omnipotence in standing over a model and that, he assumes, is why children, society's most powerless members, love them so much.

But if miniatures can draw us in, they are also capable of producing the opposite effect. In Guy Limone's work human figures turn into what, in the eye of our rulers, we often end up as: statistics, figures (not even figurines…). A similarly dispassionate and pessimistic vision of history comes out of the miniaturized work of the Chapman Brothers. I remember once being at an art gallery trying to imagine what their work would look like in an actual toy shop: 'The Chapman Bros Super Grim Reaper Set (Now With Hitler!)'. Not quite edifying, but certainly instructive. Miniatures reflect a very contemporary vision of the human element: virus-like, unpredictable, irresponsible, out-of-scale-and-control, guilty of irreversible disasters such as climate change and capable of destroying the world with the push of a button.

Do we take such dangers seriously? Are they real? One frowns at miniaturized events in the same way as one frets, distractedly, in a very twenty-first-century manner, for some loose seconds, over faraway tragedies in the news. The arcadia may be in danger, dark clouds may be gathering over our carefully constructed utopias, but we'll just crouch here, look down and keep on playing until the storm breaks, or grown-ups come to pick us up.

Let's hope they don't show up too soon.

ADALBERTO ABBATE

In 1998, Sicilian artist Adalberto Abbate saw a brawl out of his window. His first miniature work was very simple: a street and a big crowd watching two people fighting. The artist says that all his projects are marked by a deep social and anthropological undercurrent. When reading the Italian press he often feels like a miniature himself, 'With the same problems of being fragile that my works have.' He also mentions the fact that, 'Playing games animals learn how to survive… In order to be able to face life today we should play a lot.'

'Truth in the real life is often concealed in a detail, or in the small things and events.'

Using models allows Abbate to construct a world that is all about truth and the present. With the series *Microsculptures* his intention was to show the complicated facets of contemporary horror and mistake, as well as the tragicomical frailty of life.

Abbate is not especially keen on the Italian art world, saying that, 'The Italian artistic environment is filled with political favouritism, so I prefer to do everything on my own.'

RIGHT
SMILES AND SHOTS
MIXED MEDIA

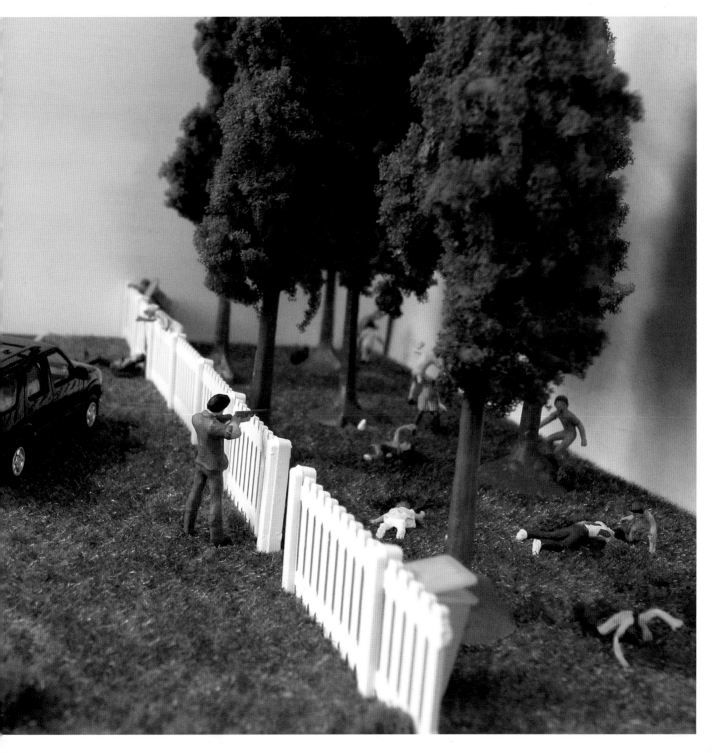

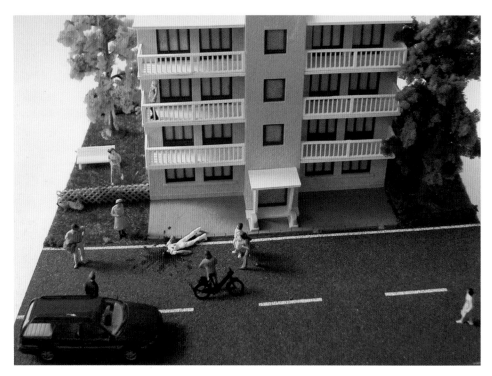

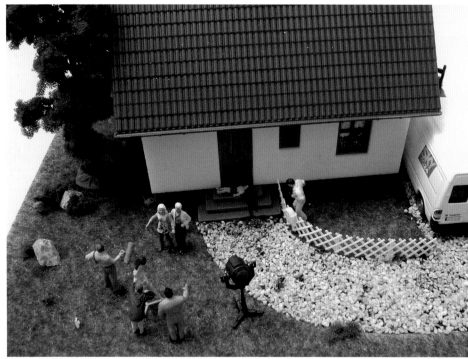

ABOVE LEFT
SECOND FLOOR
MIXED MEDIA

LEFT
COGNE
MIXED MEDIA

RIGHT
MIRACLE IN THE PARK
MIXED MEDIA

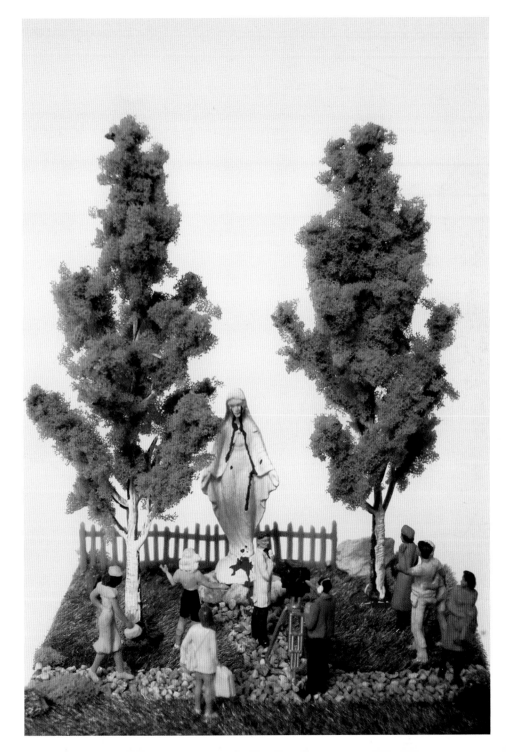

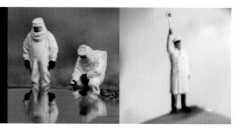

JASON
BARNHART

Photographer Jason Barnhart has always had an acute sense of scale. Miniatures were almost totemic for him as a child and he would carry one or two in his pocket. Nowadays, he often finds himself imagining massive worlds and loves to sail and rock climb – activities that remind him of how big the world really is. For him, miniature images are less about one being small than they are about the world being huge. He says he actually tries to avoid the feeling of miniaturization as much as he can. He wants the opposite effect.

Barnhart avoids Photoshop because he feels that 'using miniatures frees the viewer to make that jump, suspend disbelief, in a way that Photoshop can't achieve' and he works with the standard (train-set building) HO scale (1:87), using the miniatures as the 'anchor' for the image and extrapolating everything else out as a factor of logarithmic proportion. This is admittedly done very loosely, but he says he can usually tell if it's close to the ideal by looking at an image. If it doesn't work out mathematically, it won't work visually.

The piece *Spill* may have a particular echo since the latest oil disaster, but for Barnhart it's just a chocolate spill with a couple of guys in Hazmat suits investigating it. However, he says, if you feel strongly about pollution, eating locally, avoiding sweets, or oil dependency, there are resonances in the piece, along with a lot more of whatever else is on your mind.

'Big rooms in caves, cathedrals, underground quarries and rambling passages that feel (and are) big enough to get lost in are just magic for me. That's more the effect I'm after.'

RIGHT
SUSTAINABLE HOUSING
DIGITAL PHOTOGRAPH

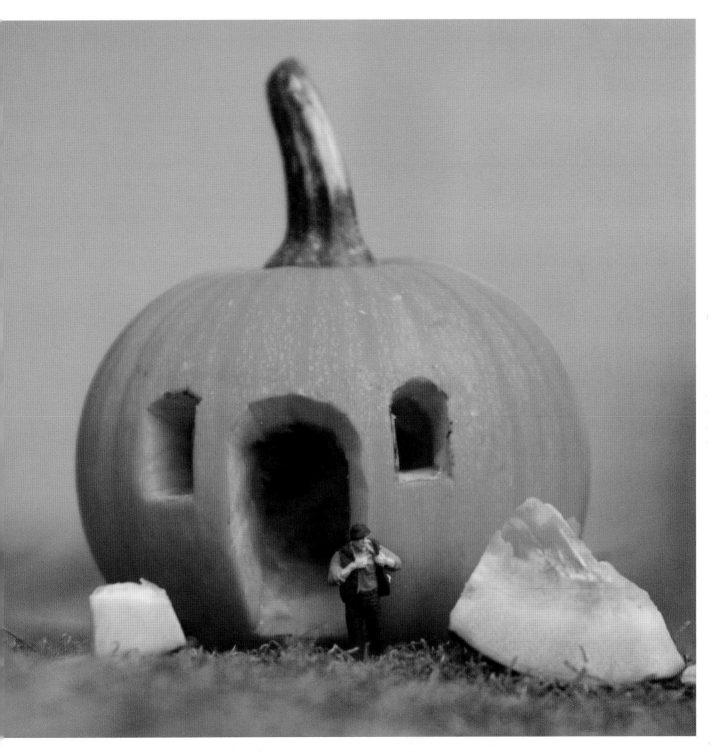

BELOW LEFT
THIS IS NOT A PIPE
DIGITAL PHOTOGRAPH

ABOVE RIGHT
ICEBERG DEAD AHEAD
DIGITAL PHOTOGRAPH

BELOW RIGHT
SPILL
DIGITAL PHOTOGRAPH

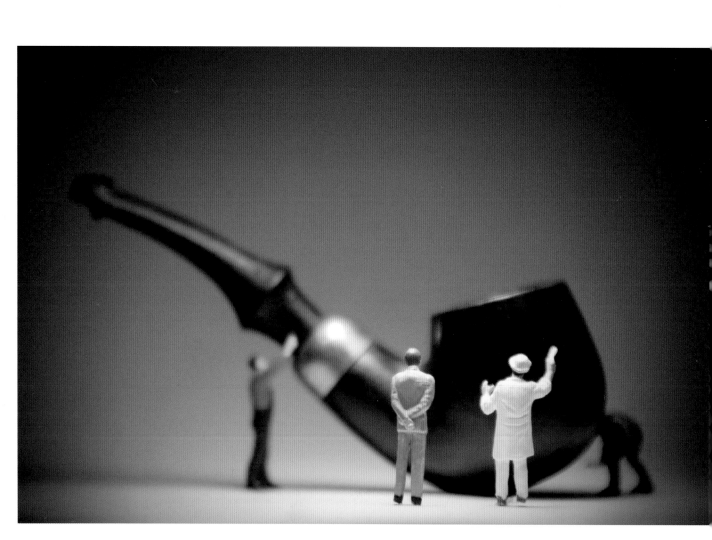

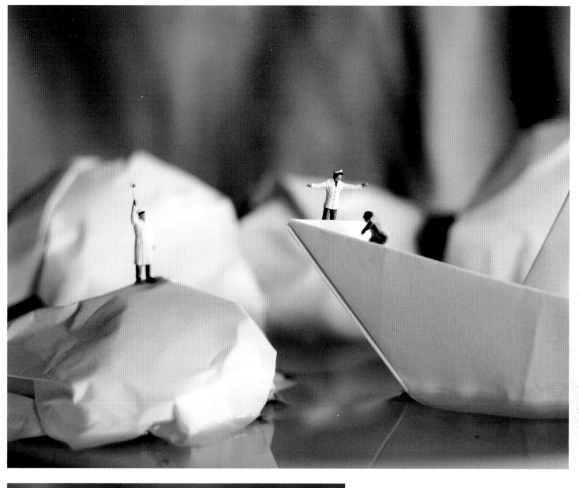

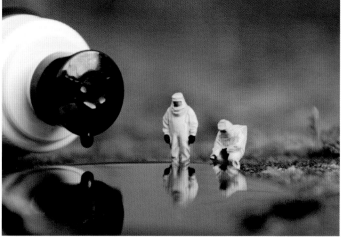

CORINNE
MAY BOTZ

In *The Nutshell Studies of Unexplained Death*, Corinne May Botz used a large format camera to photograph 18 crime scene models that were built in the 1940s and 50s by progressive criminologist Frances Glessner Lee (1878–1962). The minuscule crime scenes were based on real-life homicides, suicides and accidental deaths for the purpose of training detectives. With the assistance of a carpenter, Lee constructed approximately three models per year. They were built on the scale of 1:12 and show an astounding level of precision and craft.

The models are a reminder that the domestic space can be safe yet also terrifying: a stage for sexual conflict, obsession, transgression and demise. They contain incredible contrasts, appearing cozy yet horrifying, childlike yet adult. The photographs foreground the plight of the predominantly female victims, who suffered violent deaths in their own homes, and so bring emotion to the crime scenes.

Like a detective, May Botz also spent years researching Lee's life, conducting interviews and photographing the houses she lived in. In these photographs, she references noir photographers such as Weegee and fictional dollhouse narratives by contemporary photographers like Laurie Simmons. This play between real-life crime and fiction was also at work in Lee's constructions. Although the models were used for scientific training and Lee accurately represented details of the crimes (the angle of the blood splatter and the coloured flesh that often signals the manner and time of death), the models are very subjective and reflect Lee's biases. The interiors are similar to detective stories because they establish a mood and inform us about the victim and perpetrator. Lee also included personal details such as a miniature painting above the mantlepiece in *Living Room*, which is a copy of one in her own cottage. May Botz loves this interplay between real and imaginary, fact and fiction, in the models.

'I met an obsessive dollhouse collector who was also a prosecutor. There were no dolls in her dollhouses because she saw murder and abuse in her daily occupation and wanted to create "perfect worlds".'

RIGHT
THREE ROOM DWELLING
(BABY'S CRIB)
(FROM THE SERIES *THE NUTSHELL STUDIES OF UNEXPLAINED DEATH*),
C-PRINT

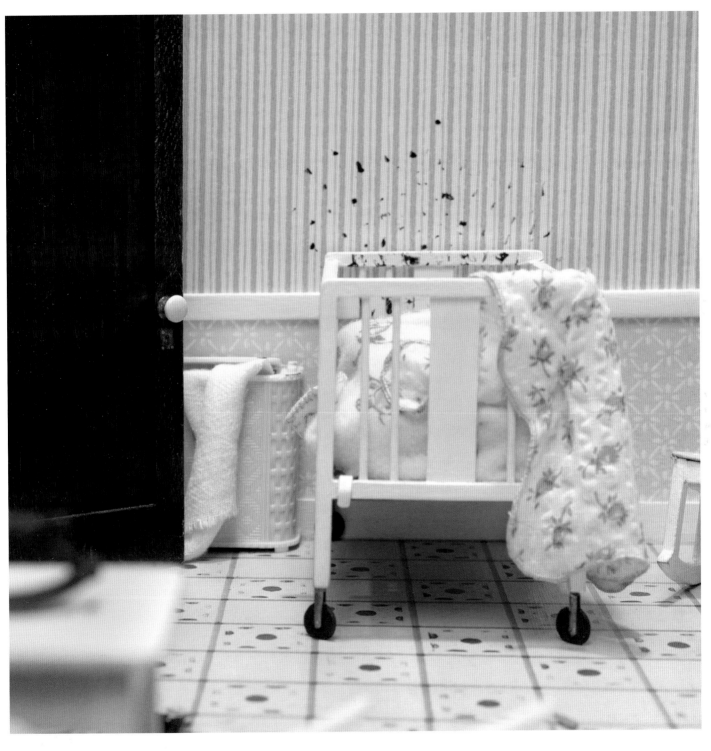

RIGHT
<u>PARSONAGE PARLOR</u>
<u>(DOLL)</u>
(FROM THE SERIES *THE*
NUTSHELL STUDIES
OF UNEXPLAINED DEATH),
C-PRINT

BELOW RIGHT
<u>BURNED CABIN</u>
(FROM THE SERIES
THE NUTSHELL STUDIES
OF UNEXPLAINED DEATH),
C-PRINT

FAR RIGHT
<u>BLUE BEDROOM</u>
(FROM THE SERIES
THE NUTSHELL STUDIES
OF UNEXPLAINED DEATH),
C-PRINT

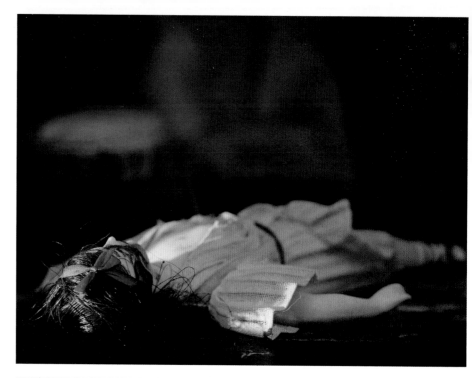

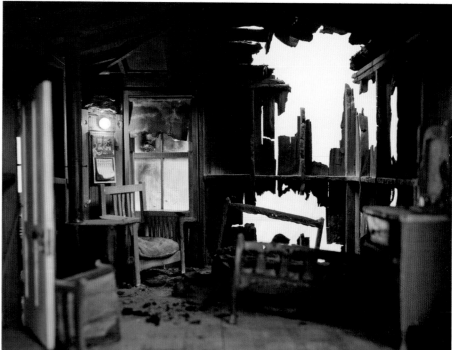

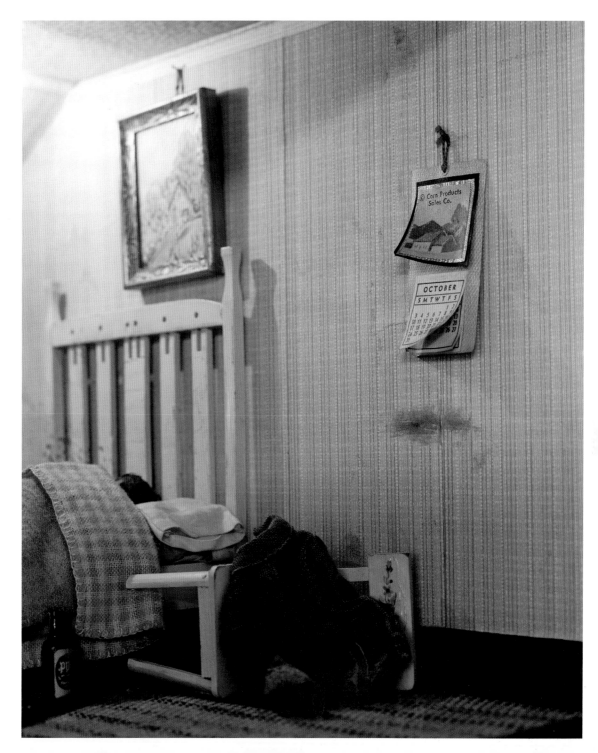

BELOW LEFT
DARK BATHROOM
(FROM THE SERIES *THE
NUTSHELL STUDIES OF
UNEXPLAINED DEATH*),
C-PRINT

BELOW RIGHT
KITCHEN
(FROM THE SERIES *THE
NUTSHELL STUDIES OF
UNEXPLAINED DEATH*),
C-PRINT

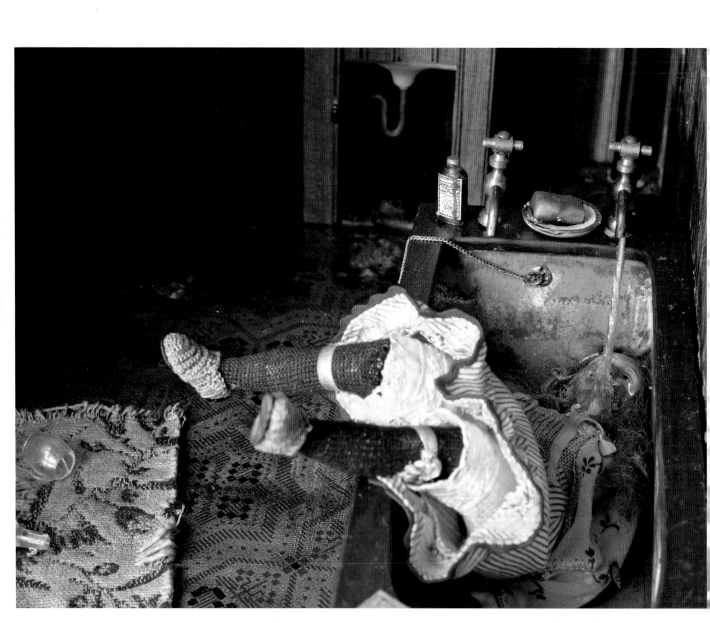

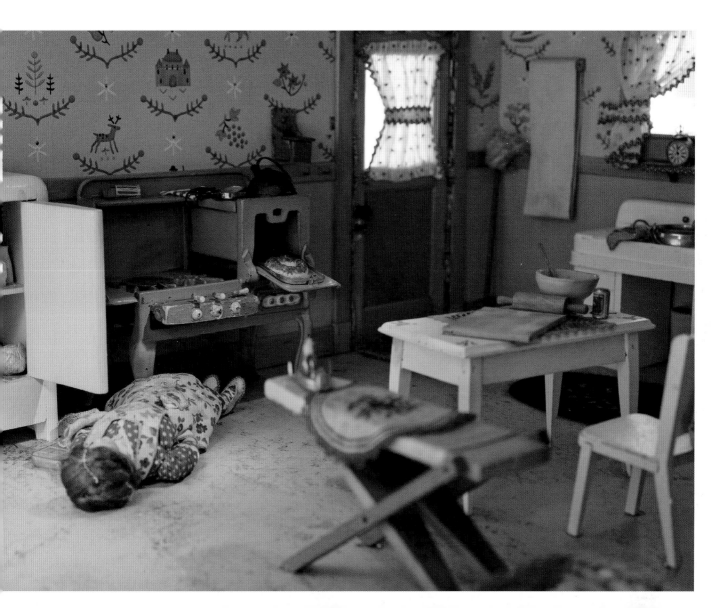

VINCENT BOUSSEREZ

French photographer Vincent Bousserez first thought of working with miniatures in 2008. There was a small model train shop in front of the advertising agency where he was working that he initially hadn't noticed. One day a friend took him there and showed him the characters, and he thought that he could buy one, take it home, play with it and try to photograph it in different situations. So he carried that first miniature with him and took a photo. Then he took another in a different setting. After that he was hooked. He went back to the shop and bought another figure, and the series went on like this. It was a game. He was playing with his friends, taking everyday items to create the settings, using a big zoom so that you wouldn't see the items in the same way, so you wouldn't even recognize them.

'When I was ten or eleven, I started to reproduce photos that I took in hyperrealist style. I loved to do it. I was addicted to it. I did it for six years. The connection is in the perfectionism, the precise outcome.'

The spontaneous aspect of the work is very important. It can take one or two hours for him to get from idea to end product. He says he likes the fact that the process is ephemeral and unplanned and, being French, he describes the pictures as not being very intellectual, 'but very spontaneous. I think about a joke, I will play with the joke, realizing it in an hour or two. I will think about it and won't wait, just like a play on words.'

When asked about the relationship between his work and the typically urban environments it represents, he says he can't help seeing cities as ants' nests. When he is in the subway or on his scooter and he sees everyone rushing around, they seem to him like insects in the jungle.

ABOVE RIGHT
WALL PAINTER
FAR FROM HIS CITY
LAMBDA PRINT

RIGHT
SPECIAL SKATING
LAMBDA PRINT

FAR RIGHT
THE BARBER
LAMBDA PRINT

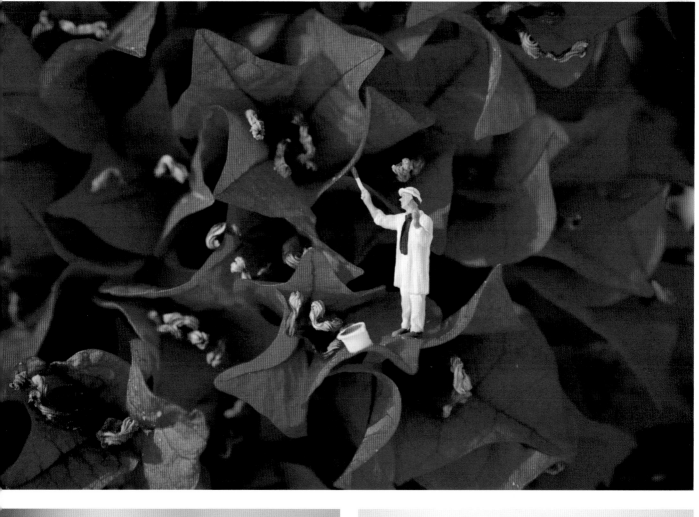

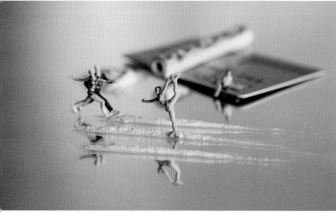

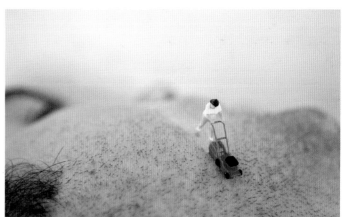

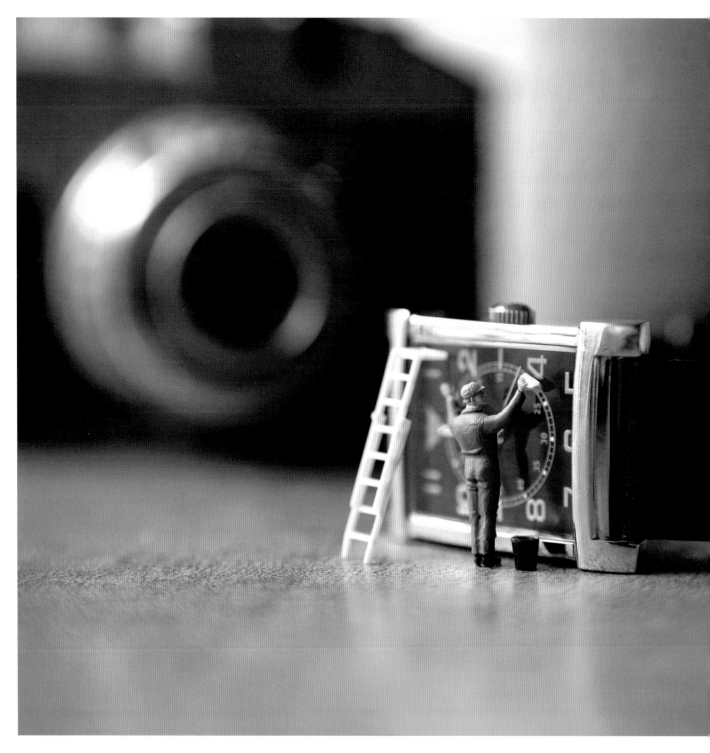

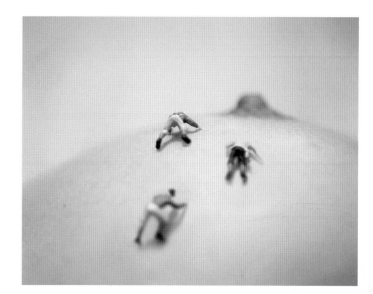

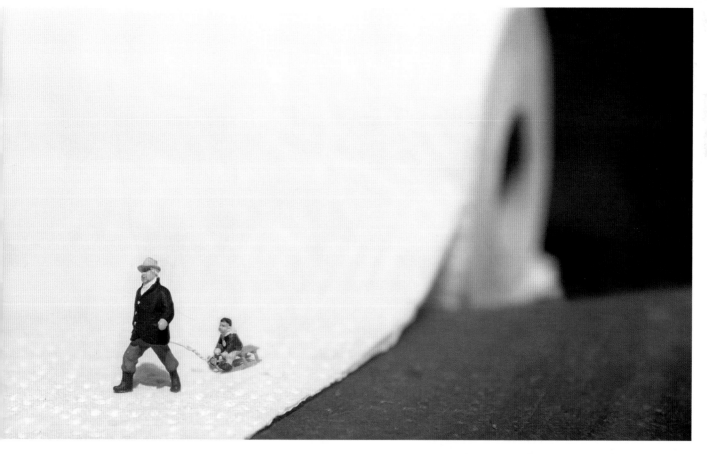

JAKE AND DINOS CHAPMAN

Childhood nightmares have always been an important element in the work of Jake and Dinos Chapman, but in *Hell* (2000, destroyed in a warehouse fire in 2004), and in *Fucking Hell* (2008), we are immersed in an archetypal twentieth-century nightmare.

'History is a nightmare from which I am trying to awake,' Stephen Dedalus declares in Joyce's *Ulysses*. Stephen is saying this almost as a joke. It's a young man trying to be clever. But his words echo, and could somehow have been a motto for the art of that whole century. Has any of us managed to awake from the nightmare of twentieth-century history?

The Nazis may have lost the Second World War, but they certainly won the 'unconscious propaganda war', the battle for our nightmares. It was impossible to grow up in the twentieth century without having those images, those mountains or lakes of gaunt naked bodies, somewhere in the back of our minds. When it came to providing horrifying evidence of human madness and cruelty, the twentieth century is unsurpassed. Not a day went by without a shocking picture popping up in the paper, or on television. We sat with our families and we watched. The 'nightmare of history' was standard fare for the twentieth-century youth.

Rather unsurprisingly, 'shock value' is a notion contemporary artists have often struggled with. To create shock, these days, one must do more than just create or recreate a shocking image. In fact, one must first manage to re-create innocence itself. And this is precisely what Jake and Dinos Chapman are so skilful at doing: creating first a sense of innocence, and then one of shock.

When confronted with one of these installations, anyone who has ever played with a set of toy soldiers or figurines can understand and identify with their language and the first impression is one of reassurance and fun. Wow, so many figures to play with! Then comes the twist: but why are so many of them lying down… Naked… Who is that fellow with the moustache? Isn't he… One can almost hear Oskar Matzerath tin drum beating in the background. The art historical references add yet a further twist in the tale. This is art, isn't it? Lovely. Remember good old Hieronymus? You thought he was joking when he painted those scenes in that tryptic? You can't be suggesting that we take those preposterous horrors literally. Are you?

Well, it's a funny old game, this history game…

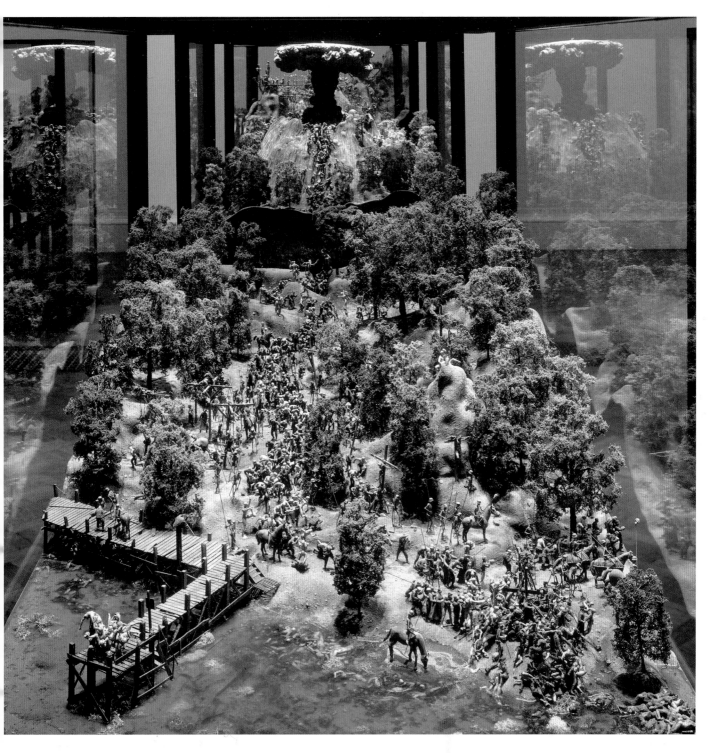

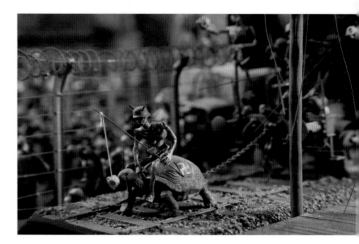

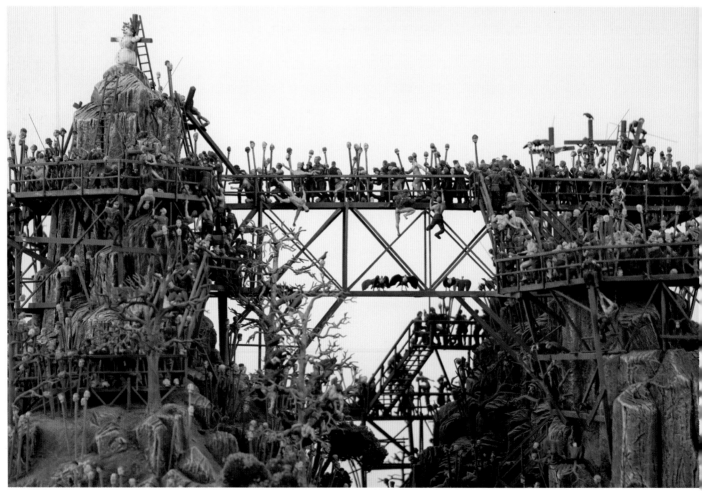

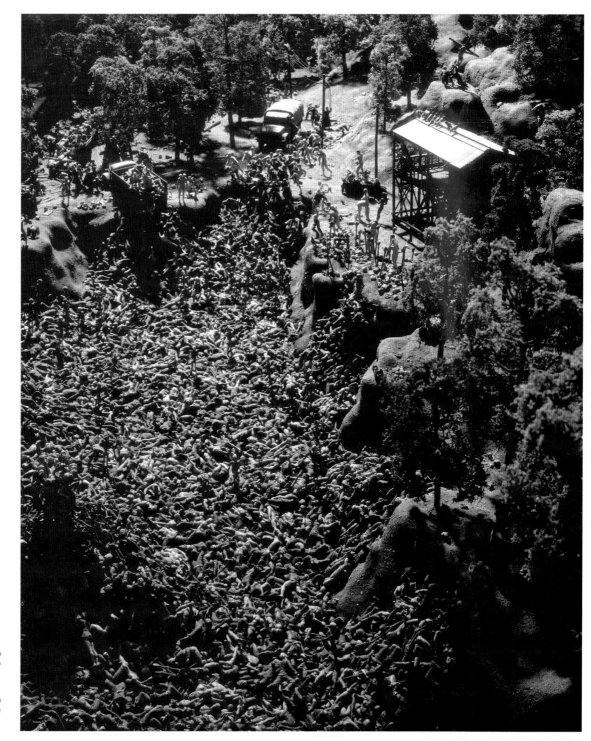

SHAOXIONG CHEN

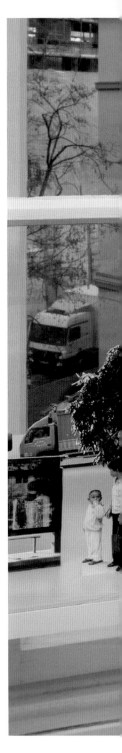

Miniatures take on particular significance when in the hands of a Chinese artist: 'When walking the streets, I see a great number of people and when you see so many people there, you realize how small you are. That is where my inspiration comes from. The *Streetscape* and *Homescape* series were meant to produce a specimen of city life. I live in it, so it seems like my responsibility to record what I see and feel.'

Despite often being called a 'conceptual' artist, Shaoxiong Chen says he never starts with a concept, or even with a sketch or a paragraph. He says he simply does things while walking the streets. He has a strong interest in everything related to the city, which he takes lots of pictures of, later editing his memories through the photos. The first time he used this method was in 1997; he found that it captured something of what he felt in

'Everything in this city is temporary: streets, buildings, shopping centres, train stations, airport, transit ways, trees, road marks etc.; even the crowds. No matter permanent or temporary residents, nothing is fixed.'

the streets, quite accidentally. He says he was quite moved when he saw his memories all collected in the *Streetscape* series.

As for his background, Shaoxiong Chen just says he was born into an ordinary family, and studied at ordinary primary and middle schools in a very ordinary city. He also says that when he was a baby, the first sentence to come out of his mouth was, 'I want to be an artist'. At the same time, he says, he still hasn't decided whether he wants to become an artist or not, as he still has no idea what art really is.

RIGHT
STREETSCAPE (2005)
INSTALLATION WITH
PHOTO-CUT COLLAGE

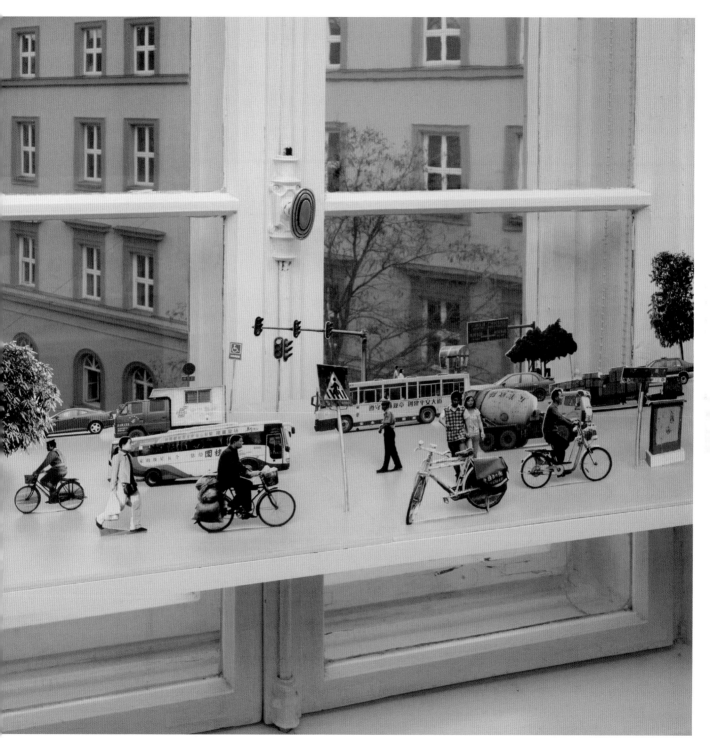

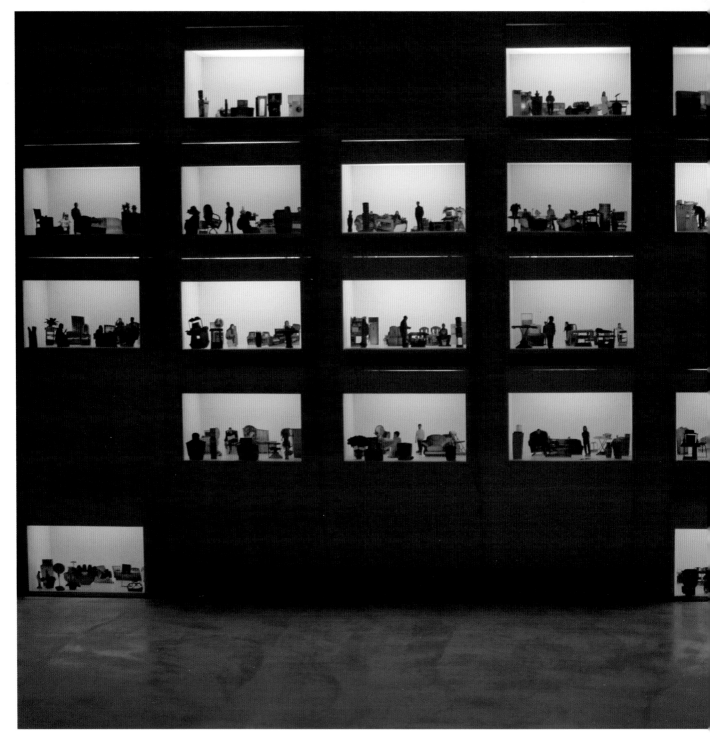

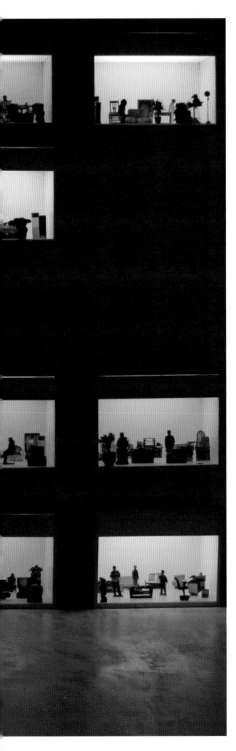

LEFT
HOMESCAPE (2005)
INSTALLATION WITH
PHOTO-CUT COLLAGE

BELOW
HOMESCAPE (2002)
INSTALLATION WITH
PHOTO-CUT COLLAGE

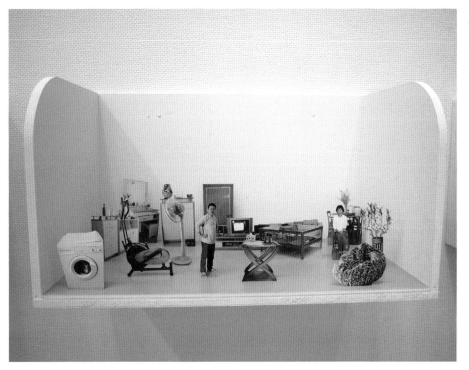

ETIENNE CLÉMENT

Artist Etienne Clément describes himself as 'coming from architecture. And, in particular, ruined architecture.' For years, his photographic work was about dereliction and the massive size of landmarks like Battersea Power Station. Then he started wanting to create a kind of narrative within these spaces. When photographing derelict architecture he would break into the same kind of areas as those he liked to play in as a child, when he was fascinated by all the leftover materials one could find – a lot of them toys – which he would take home and use to try to recreate their environment.

As a mature artist he has started doing the same thing in his work. The series *Toy Story* essentially began as portraiture, but then gradually moved towards narrative. Thresholds open on to the outside and all of a sudden it's much more than just one person on a backdrop. Clément gets figurines off eBay and uses differences in scale to enhance perspective. He loves the modelling aspect of the process, 'I put my radio on and work on my stuff. It is an extension of my childhood.' More and more of the work is done before taking the photograph – it takes him four or five months to create a model and stage a story, then it takes him just a day to shoot it, or sometimes even less.

'Ruined architecture is my world, I love it.'

His last work *Temperance, Fortitude… Celebrity* is loosely inspired by a mural about the virtues of good government in a public palace in Siena. It made him wonder, 'Nowadays, do we still believe in these virtues? What do we believe in now?' Celebrity was the only answer he could come up with and it formed his starting point for the piece. 'We are basically in Buckingham Palace. There is the Queen watching her favourite horse race, surrounded by cake and booze… She's chilling at home and people come to see her as if she were in a zoo.'

In spite of the fact that his inspiration often comes from the past, Clément's concerns are current ones. The cryptic *'Eat cake!' Says Queen* is about the French Revolution, but also about the press. He compares the pamphleteers who spread wild rumours about Marie Antoinette (such as the infamous 'let them eat cake' quote) with the current role of tabloid newspapers. No one era has a monopoly on vulgarity.

RIGHT
TEMPERANCE,
FORTITUDE… CELEBRITY
LAMBDA PRINT

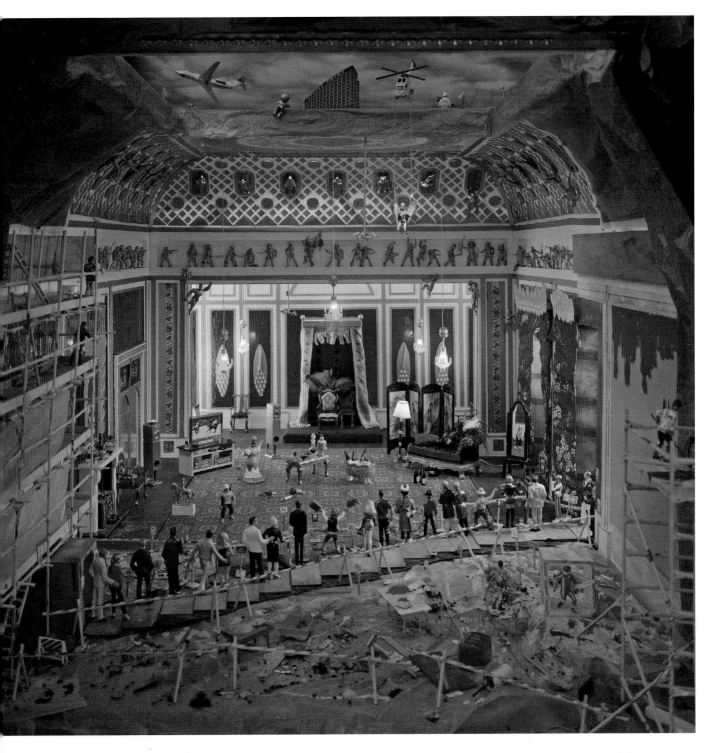

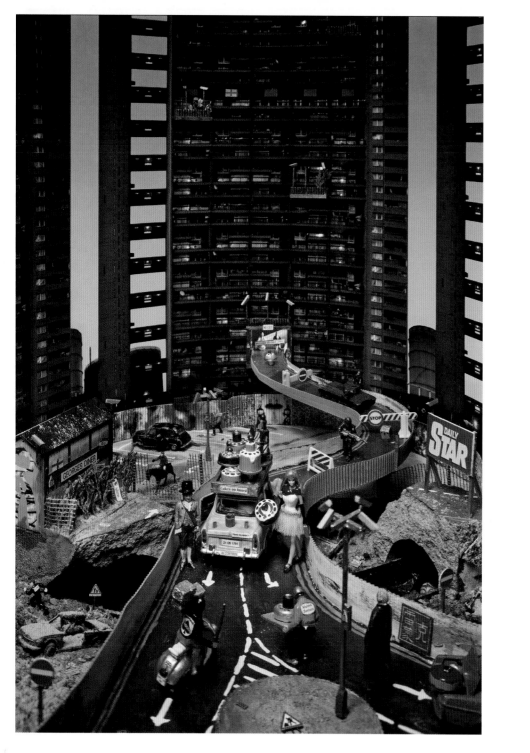

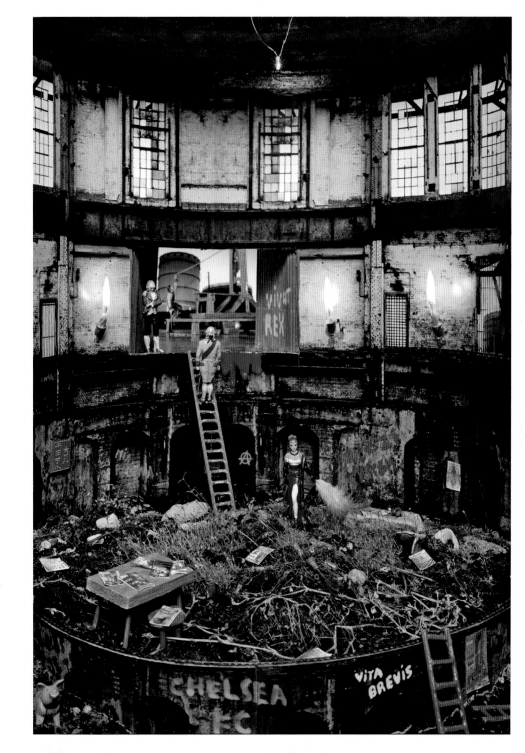

LEFT
LA NUIT DE VARENNES
(FROM THE SERIES
'EAT CAKE!' SAYS QUEEN),
LAMBDA PRINT

RIGHT
VITA BREVIS
(FROM THE SERIES
'EAT CAKE!' SAYS QUEEN),
LAMBDA PRINT

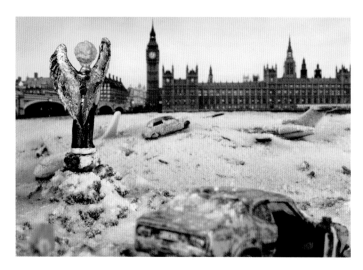

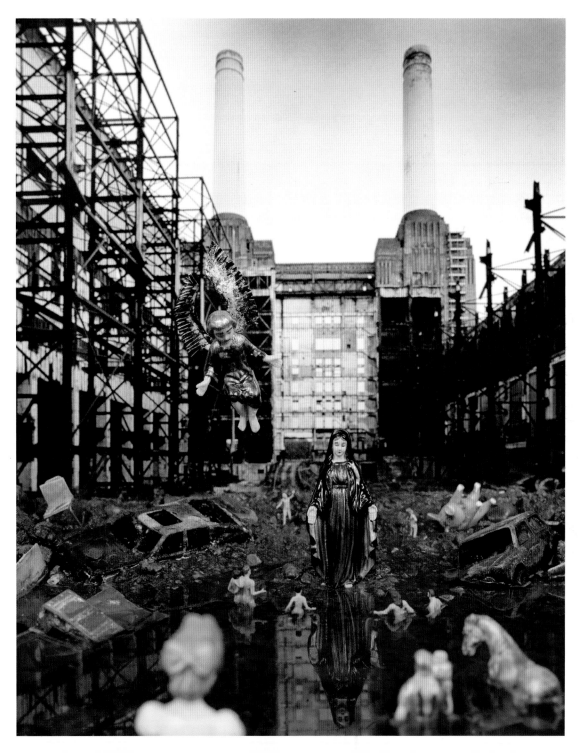

NICHOLAS COBB

After art school, Nicholas Cobb spent a number of years painting abstracts, before a complete about-turn in 2005 found him creating and photographing plasticine and junk material figures in dioramas.

The artist says he has no training in model-making and hasn't read or researched any techniques. 'Perhaps on reflection I should,' he adds. He also confesses to relying on throwing things out of focus to disguise glue marks and joints that won't quite fit. He says he wouldn't get a job doing this.

Cobb uses existing building developments for the general look of the model sets. He draws from aerial photographs and visits the sites for further photographic records, but they are not exact copies. There were two models for the *Office Park* series of photographs. The first was at 1:50, an architectural model-maker's scale (apparently one can get a small range of office-worker figures with these). The second model, with all the office blocks, was made at the railway enthusiast's HO, 1:87, scale. The enormous range of suitably sized model train-set figures available from Germany, both ready painted and not, dictated that. The overall size was 2.4 by 1.2 m (8 by 4 ft). The 'white look' of architectural models is cultivated purposefully as Cobb's work portrays a heavily J. G. Ballard-influenced dystopian view of late capitalism.

'The jumps in scale are important. The Lilliputian appearance draws the observer in. In some of my work I have larger-scale model figures observing an incident taking place on a smaller scale still.'

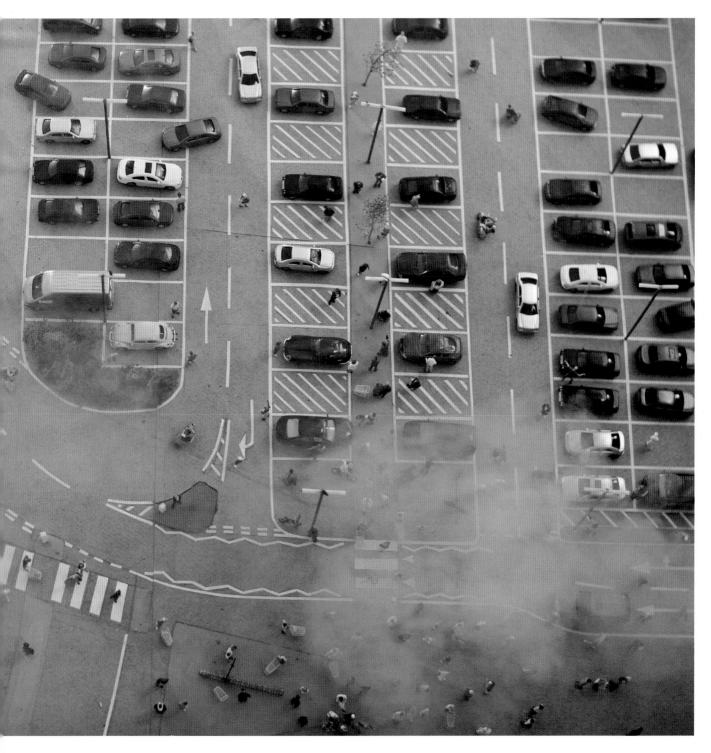

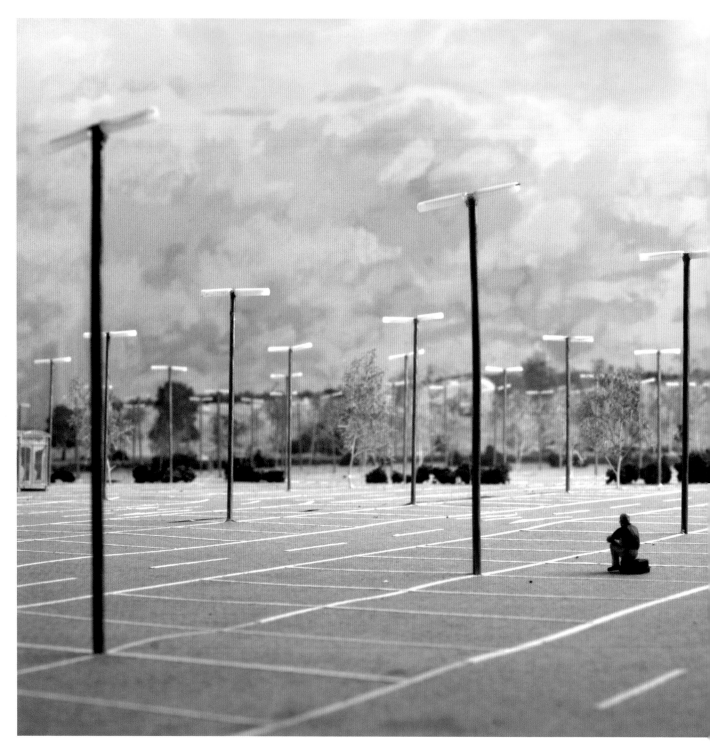

LEFT AND BELOW
UNTITLED
(FROM THE SERIES
THE CAR PARK),
GICLÉE PRINT

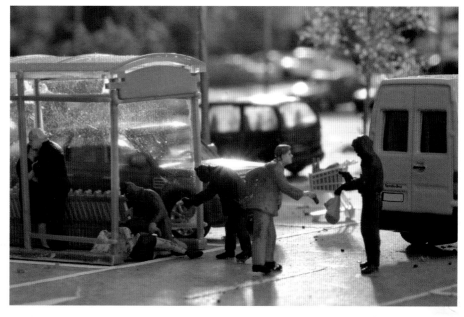

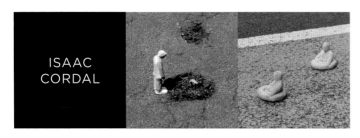

ISAAC CORDAL

Isaac Cordal lives in London. Working on a small scale allows him great freedom of movement. He can carry 20 pieces in a bag and go for a walk around the neighbourhood with them. Generally, he doesn't use pieces taller than 25 centimetres. The idea is that the city becomes decor for the sculptures, and they are camouflaged within the urban furniture.

Sometimes he puts the sculptures in his backpack then, walking out in the streets, he finds situations he could never have imagined, or places that could have potential, and so he creates a sculpture from scratch just for that particular location.

'I think it is very important to observe what surrounds us and how we can manipulate delicately something to change its meaning.'

Cordal is mainly interested in the process of placing pieces in public spaces. He likes this ephemeral element of the sculptures, lost in the urban jungle, and the fact that anyone can become an involuntary spectator. Even if just passing by, one becomes the new owner, or collector, of one of the pieces.

His work reflects environmental concerns, trying to focus attention on our devalued relationship with nature. He presents fragments in which nature, still present, shows encouraging signs of survival. Cordal says his small, anonymous sculptures contemplate the demolition and the reconstruction of everything around them and draw attention to the absurdity of our existence.

ABOVE RIGHT
RED PAINT UNDER MAN
LOCATION: BARCELONA,
CEMENT SCULPTURE

RIGHT
IKEA THRONE
LOCATION: PONTEVEDRA,
CEMENT SCULPTURE

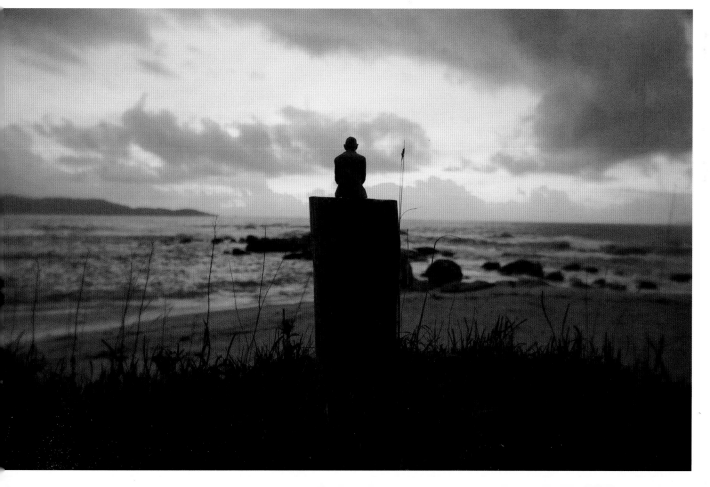

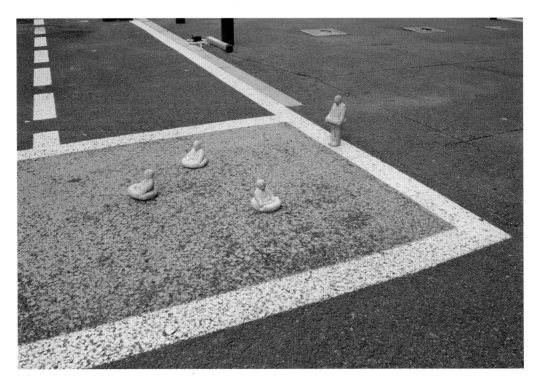

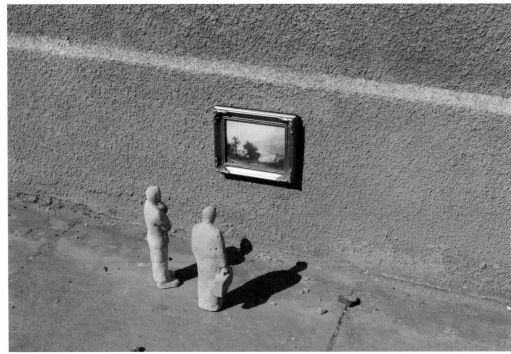

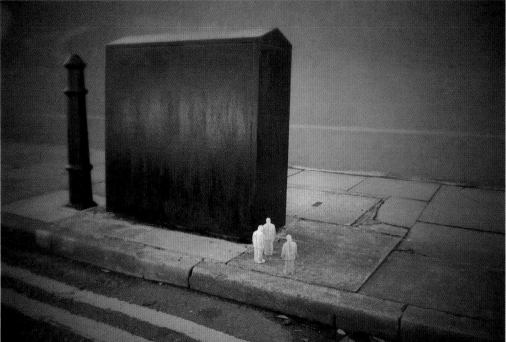

ABOVE FAR LEFT
PUBLIC SWIMMING POOL
LOCATION: LONDON,
CEMENT SCULPTURE

BELOW FAR LEFT
REMEMBRANCES
FROM NATURE
LOCATION: LONDON,
CEMENT SCULPTURE

ABOVE LEFT
REALITY SHOW
LOCATION: LONDON,
CEMENT SCULPTURE

LEFT
HOME
LOCATION: LONDON,
CEMENT SCULPTURE

BELOW LEFT
FOLLOW THE LEADER
LOCATION: LONDON,
CEMENT SCULPTURE

BELOW RIGHT
FOREST ROAD E8 3BJ
LOCATION: LONDON,
CEMENT SCULPTURE

BOTTOM LEFT
CLIMATE CHANGE
EXPEDITION
LOCATION: LONDON,
CEMENT SCULPTURE

BOTTOM RIGHT
REQUIEM FOR A PIECE
OF CEMENT
LOCATION: LONDON,
CEMENT SCULPTURE

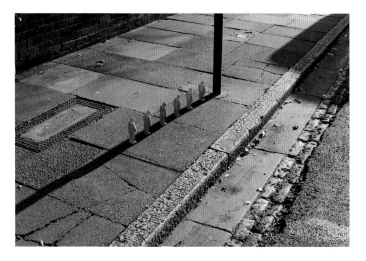

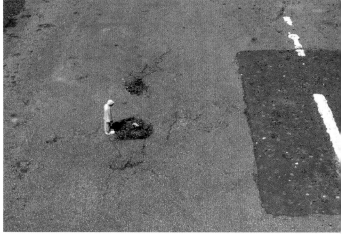

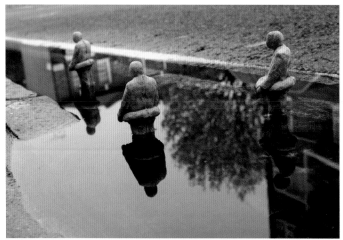

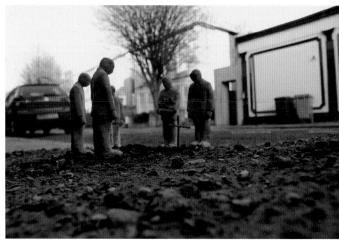

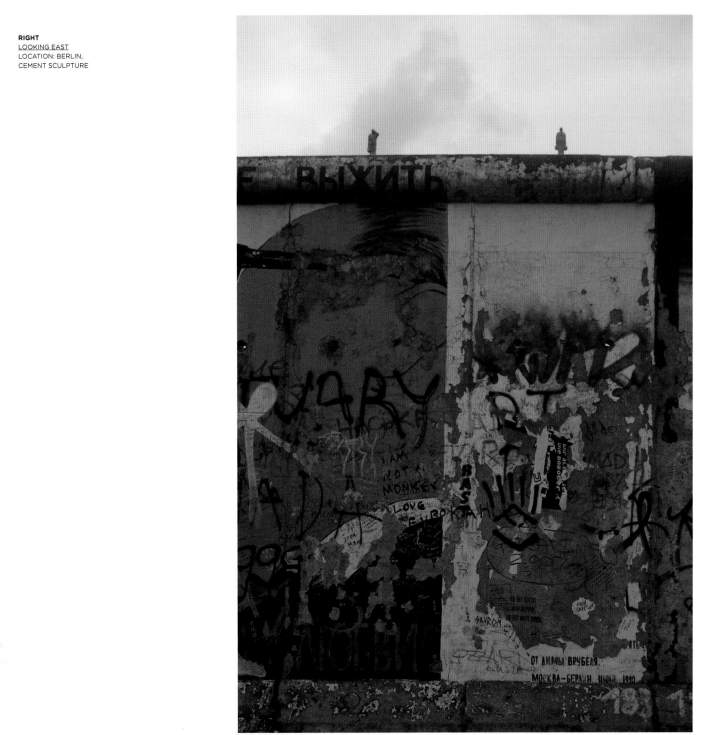

DANIEL DORALL

Was Lego® every architect's favourite toy? It was certainly Daniel Dorall's, and his interest in both art and architecture has since led him back to building on a small scale.

Dorall lives in Melbourne. Because the city layout is based on a grid, the planners included numerous narrow and sometimes hidden alleys and lanes as access routes for buildings. Many of his mazes are based on the Melbourne city grid and perimeter layout of the buildings. He sometimes wanders these alleys as they remind him of the corridors in his mazes, making him imagine what it would feel like to be a miniature in one of his own pieces.

'I make maze objects with urban and social narratives. I work in a small scale as I am interested in details and intricate structures.'

The maze objects are constructed in cardboard, a material Dorall has come to know and love and he generally works in a 1:87 scale, which is the scale of the figurines he uses. It's a very popular scale among miniature model-makers and train-set enthusiasts.

The pieces sometimes tell a story, or make a socio-political comment, but often they are studies in composition, aesthetics and the beauty of the 'handmade'. The process has many layers: the building of the walls, setting of the sand, the painting and placement of the interior layout and the finishing or surfacing of the entire work with more cardboard.

RIGHT
LIFE + DEATH
MIXED MEDIA

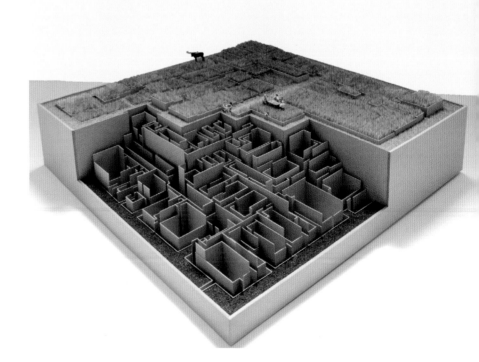

ABOVE RIGHT
FIELD
MIXED MEDIA

RIGHT
PICNIC
MIXED MEDIA

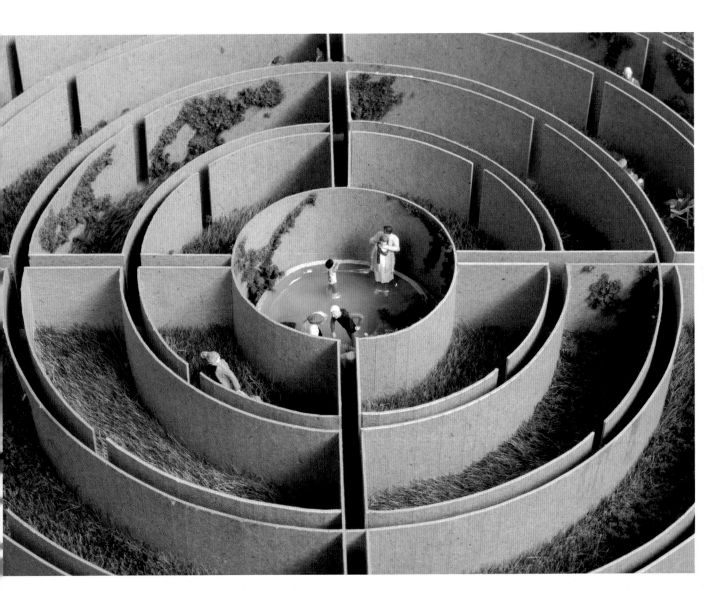

THOMAS DOYLE

Thomas Doyle builds diorama-like scenes in small scales, 1:100 to 1:43. They tend to feature people in uncanny situations and are usually displayed under glass domes. He starts by sketching out his ideas, coming at the piece from a number of angles until the narrative is right. He then leaps into the production of the piece, making small adjustments to the composition along the way and sometimes to the concept. In their largest incarnations, pieces can take him in excess of 150 hours from beginning to completion. The scale often depends on the subject matter. Larger scale scenes are usually those where human-to-human interactions are primary, whereas other works – where human beings are dwarfed by cliffs, houses or trees – may be created in smaller scales.

There is often a story behind his work, but he likes to leave these fairly ambiguous. His work tends to function like a scene one remembers after waking from a dream, 'something happened just before that moment, something happened just after, but one is focused on that one strange image.'

He thinks miniatures and models have the power to transport us to other worlds. He says that, 'There's a strange omnipotence when standing over a model, which is probably why children, our most powerless members of society, love them so much. Models also have an intimacy that's hard to achieve with other media. They can draw you in, urge you to relate to them on their level. It's a unique experience.'

'The glass contains and compresses the world within it, seeming to suspend time itself – with all its accompanying anguish, fear and bliss. By sealing the works in this fashion, I hope to distill the debris of human experience down to single, fragile moments.'

RIGHT
ESCALATION
MIXED MEDIA

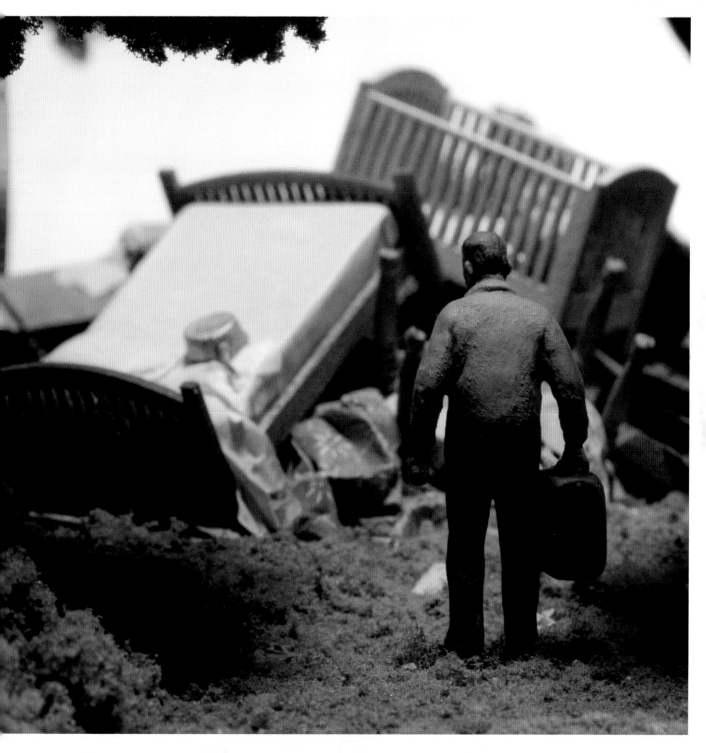

BELOW LEFT
IN LIEU OF A LAST
LAST CHANCE
MIXED MEDIA

BELOW RIGHT
CLEARING (UXO)
MIXED MEDIA

FAR RIGHT
A CORRECTIVE
MIXED MEDIA

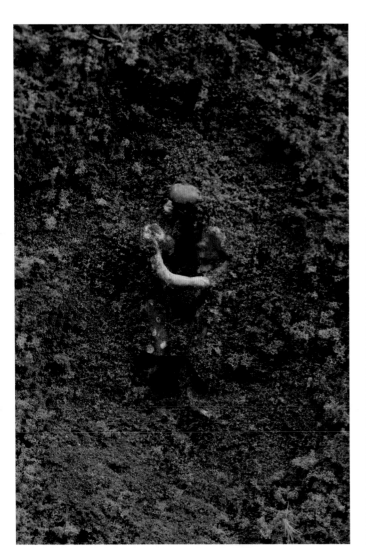

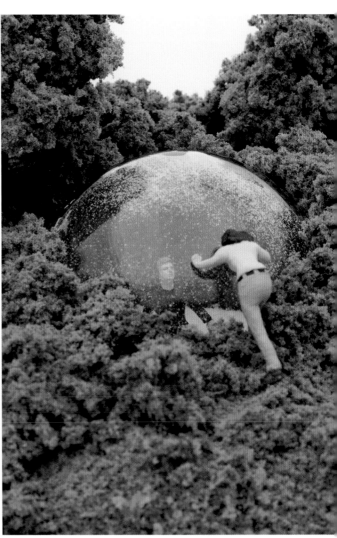

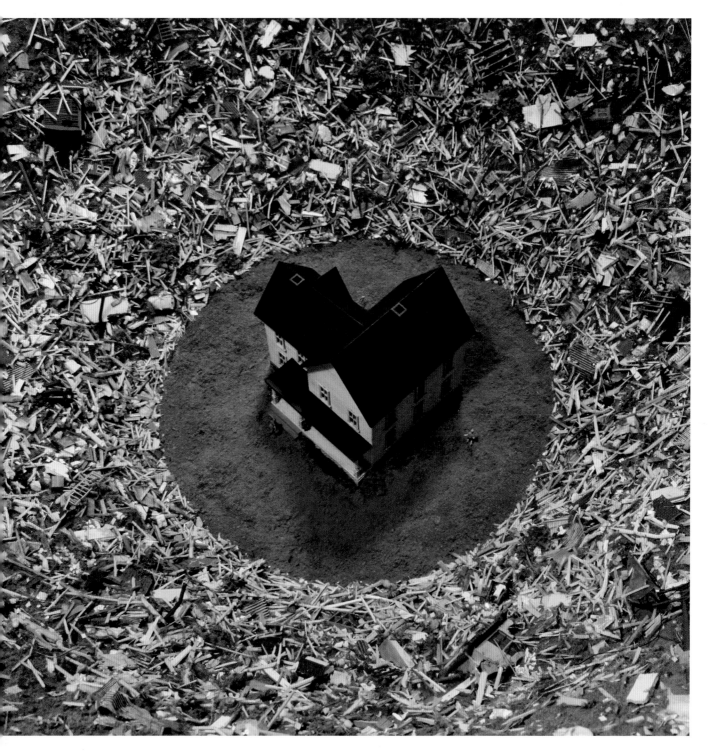

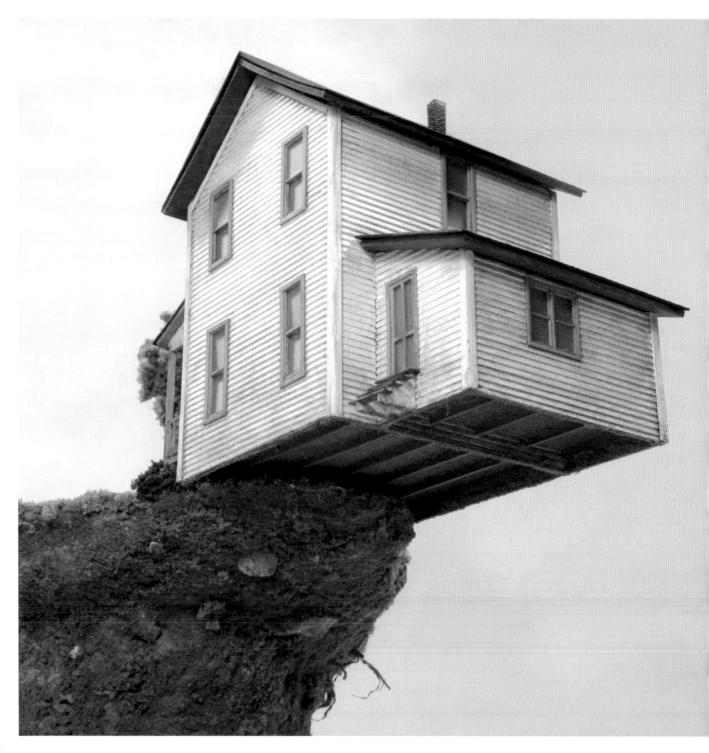

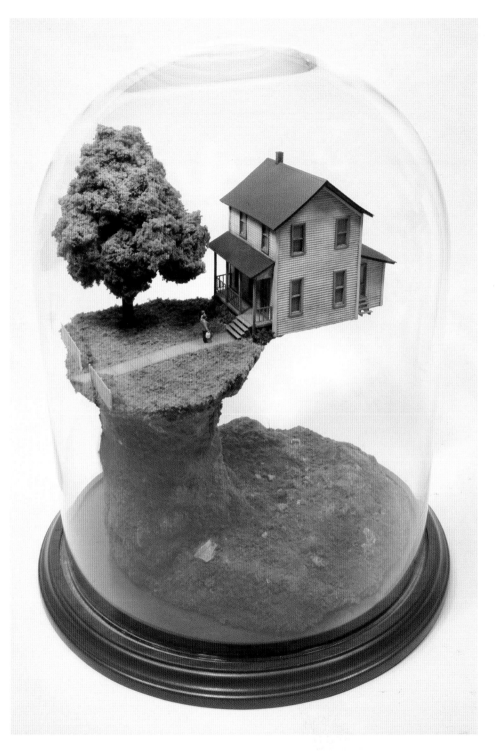

FAR LEFT AND LEFT
ACCEPTABLE LOSSES
MIXED MEDIA

GREGORY EUCLIDE

Gregory Euclide grew up in a rural section of Wisconsin. He spent most of his early days playing outdoors in the forests, fields and ponds. His father was an art teacher who built several of their homes while Euclide was growing up. His mother trained as a master gardener and also learnt to make stained glass. She would get *Mother Nature* magazine, build her own solar panels and make winter coats from milkweed stuffing. Euclide thinks a lot of this has rubbed off on him and adds that he has a tendency to see everything as interconnected.

It was at graduate school that he started working with the topography of torn paper. He placed natural elements into his work as a way of creating a contrast between the land and its depiction, and became interested in the potential for materials to have double meanings in certain contexts. He found that an authentic souvenir from a particular environment could be used to create an artificial representation of it, and adding diorama to his work became a fitting vehicle to address issues of artifice and authenticity.

Most of the materials used in his work are collected from his yard. Usually, the artist creates the scenes on the paper's topography after the vignettes have been painted. It is very time consuming to collect, dry and fabricate all the materials, but after this phase is completed, he says, it is rather fun to plonk a tree down here or there and build a little space.

Euclide moved out of Minneapolis a year ago. Now he looks at the stars every night, sees wildlife in the morning and is surrounded by nature simply by walking outside. He says he never feels like a miniature himself, as that would imply a larger element controlling him. The world is big and confusing, but he feels he can control it through how he chooses to live.

'There is something interesting that happens when we project ourselves into spaces that are smaller than we are... with the model we get caught projecting ourselves into a scene and experiencing it with our body in a way we don't experience a painting.'

RIGHT
WITH YOUR WATER
FALLING OVER OUR
NEW NATURAL
MIXED MEDIA

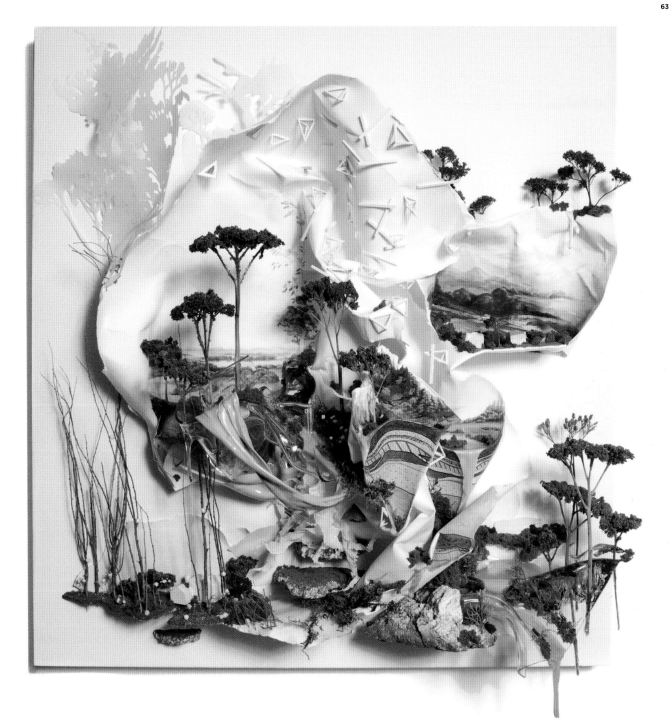

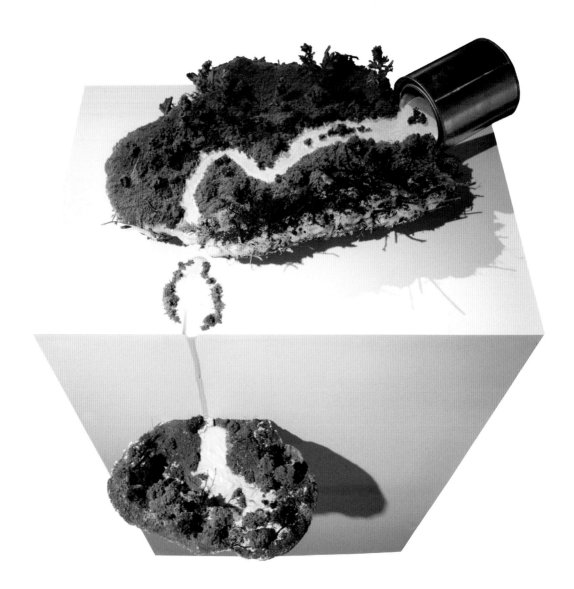

ABOVE
CAPTURE #9
MIXED MEDIA

RIGHT
I WAS ONLY THE LAND
BECAUSE I LIKED THE
PREDICTABLE STILLNESS
MIXED MEDIA

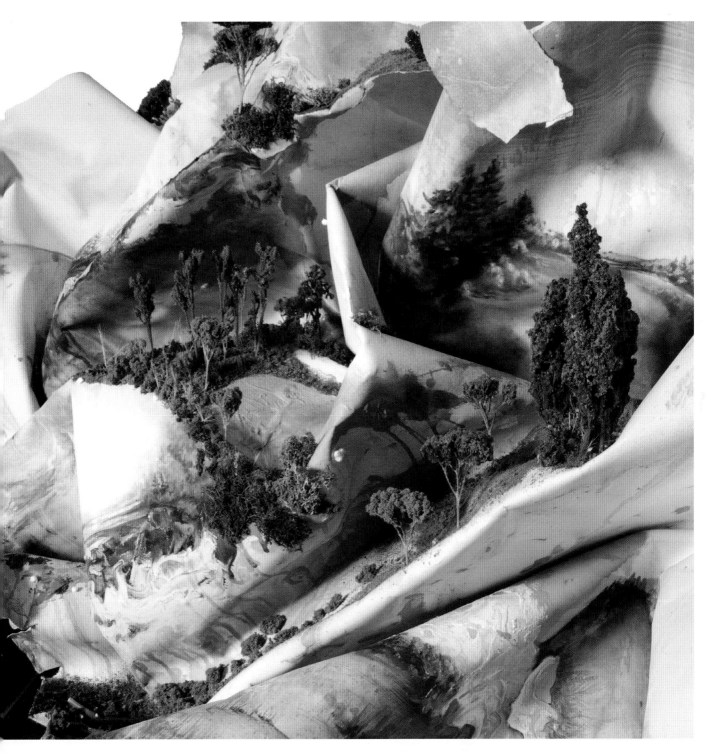

JULIA FULLERTON-BATTEN

The work for *Teenage Stories* began in 2003 when Julia Fullerton-Batten was in Wales shooting a series for teenagers. It was then that she began to relate to the theme of the teenage girl's emancipation and the transition from being a girl to becoming a woman. In these images she tries to illustrate the fragile state of pubescent pre-teenagers coming to terms with the physical, psychological and emotional changes that are happening to them.

The photographer first visits the locations and takes snaps. From there ideas develop and Fullerton-Batten starts sketching how she wants the models and props placed in the setting. She often treats models like still-life objects – they are street cast and inexperienced. She likes the particular naturalness and awkwardness she gets from street-cast models.

Initially a teenager is confronted by the changes in her body shape. She looks at and questions her position within her own mind, within her family, among her peers, in society. Sometimes she feels a stranger to herself, perhaps even more so to the world at large. Daydreaming enables her to escape this conflict of emotions. In her dream world she adopts a different role, she appears to develop a sense of increasing freedom, becoming a giant in her surrealistic dream world.

Portraying the girls in a Lilliputian environment emphasizes the teenage psyche at a specific time in their progression to womanhood – occasionally daydreaming, sometimes insecure, sometimes all powerful, often rebellious, then clumsy, lazy, energetic, involved with everyday life or indifferent, not caring about anything in particular.

'Making the girls stand as giants in their environment portrays their illusions of grandeur. Their indifferent attitude shows their aloofness towards life. This emphasizes the isolation and vulnerability that teenage girls experience during this phase of their life.'

RIGHT
REFLECTION IN
WATER (2005)
C-PRINT

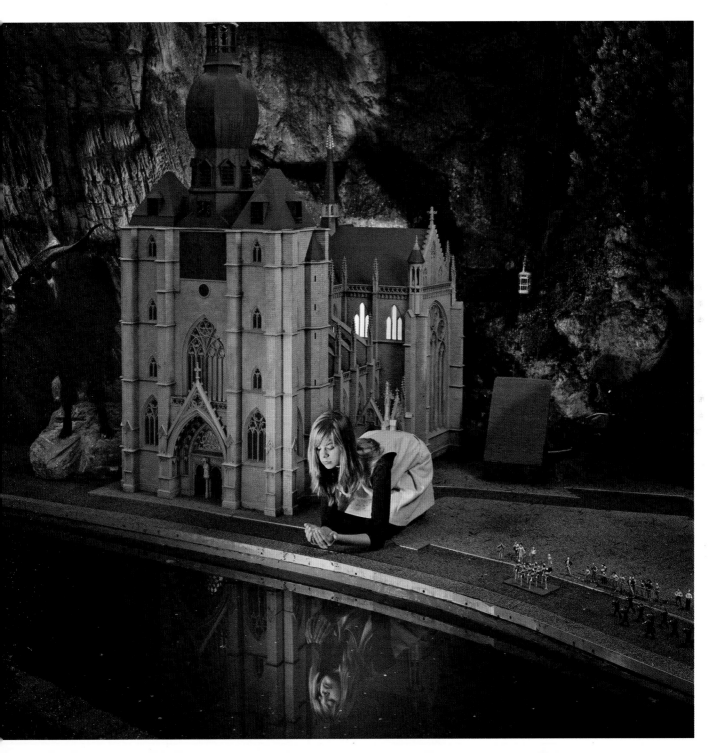

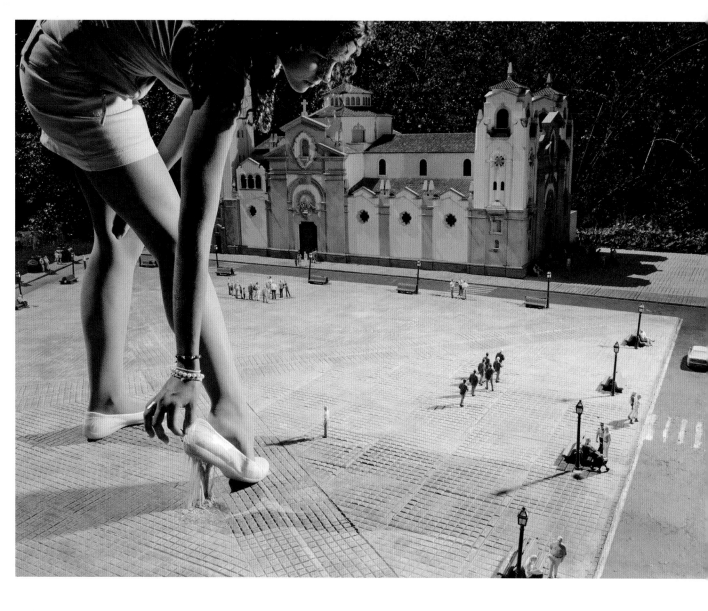

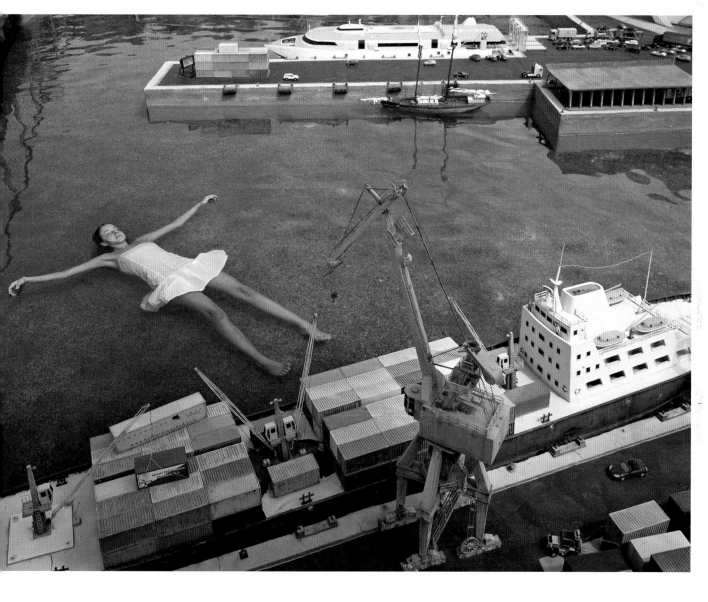

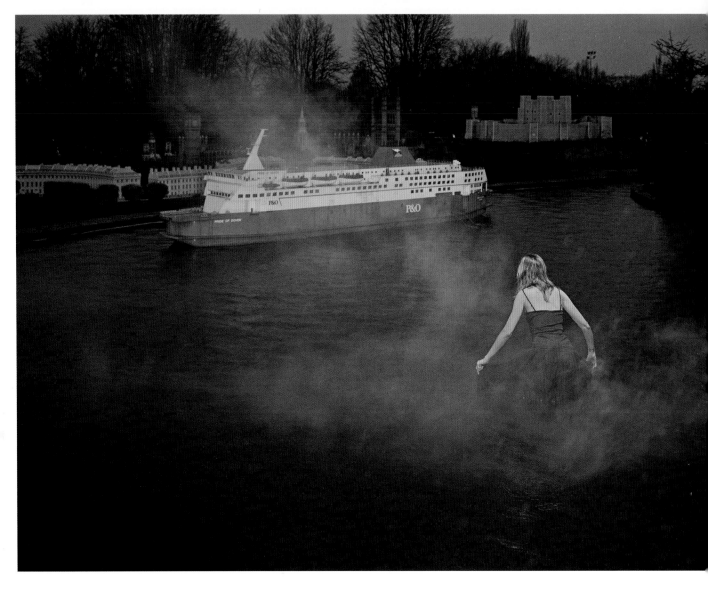

ABOVE LEFT
P&O (2005)
C-PRINT

ABOVE RIGHT
BROKEN EGGS (2005)
C-PRINT

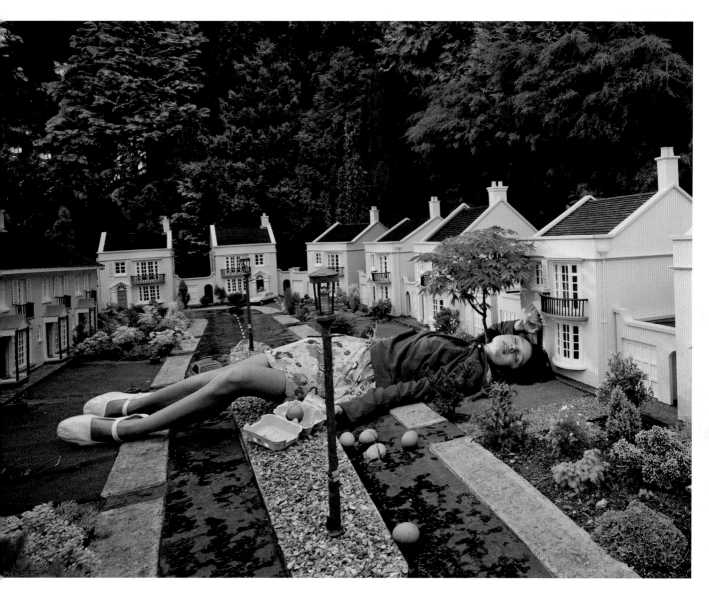

AUDREY
HELLER

When Audrey Heller was five she was given a miniature farm, with a barn, animals and people. It was her most treasured possession. She would set up one precise little scenario and leave it in place for weeks, until she re-staged the figures into another precise scenario. The farmhand with the sack of grain over his shoulder was her first crush, she realizes now, looking back.

Heller compares setting up her shots to directing theatre (she was trained as a director and lighting designer). You start with an idea of how you want a scene to go, but as you work with the specific actors and the set, you discover things that you hadn't imagined before you started rehearsing. If you insist on your predetermined plan, you will discourage the actors and flatten the performance.

'I know that sounds a little crazy, since I'm working with toys, not actors, but I know when my creations have vitality and when they feel forced.'

She loves to highlight overlooked details and visual puns, and finds it very gratifying that people of all ages and backgrounds find a personal and different way to connect to her work. People don't look at her pictures silently, they want to talk about what they see and exchange their ideas.

'Sometimes, particular figures have ongoing stories, like the scuba divers who are always looking for water, or the cycling group who are exploring.'

ABOVE RIGHT
WHAT YOU SOW
COLOUR PRINT

RIGHT
CHALLENGING CONDITIONS
COLOUR PRINT

FAR RIGHT
MEASURE
COLOUR PRINT

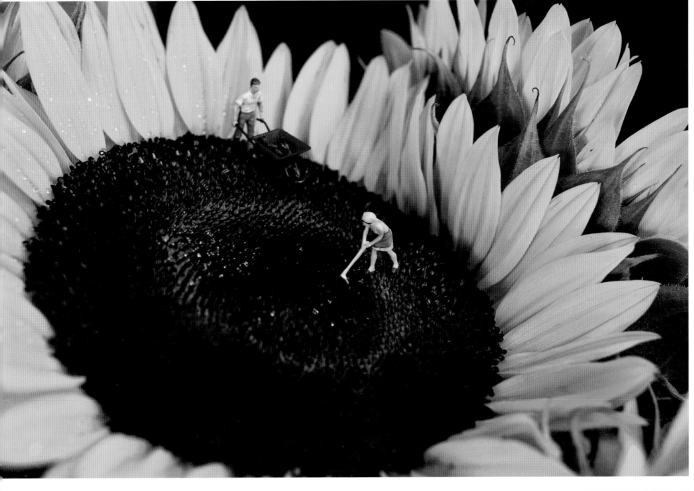

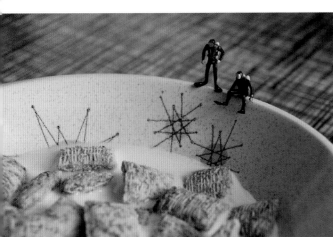

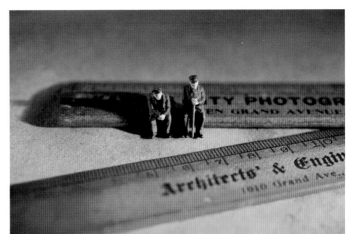

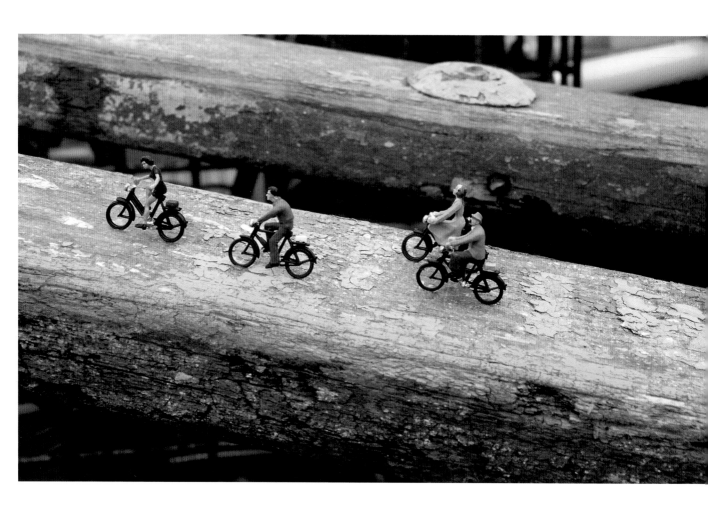

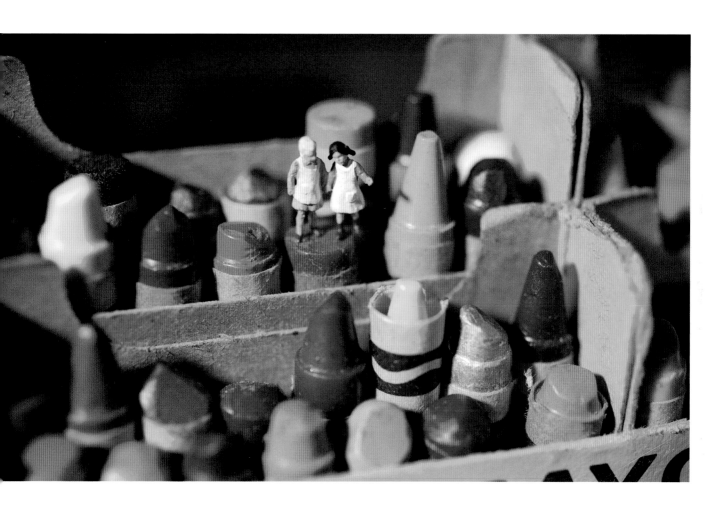

AKIKO IKEDA

Akiko Ikeda lives in Osaka. She can remember playing with toys that used to come with little caramels and candies. One of her most powerful memories is that of playing with small insects. She would capture caterpillars and watch them, or poke at ant nests in the corner of a park.

Ikeda completed a first MA in Sculpture at Kyoto City University of Arts and a second in London. Her first monograph *Their Sight/Your Site* (Seigensha, Japan) was published in 2008. The idea for the book came to her in London in 2000, as she was trying to make something out of her Dusseldorf snapshots. She works by cutting out motifs within photographs and magazines, such as people, vehicles and buildings, and making them pop up. First she spends time collecting materials, only to begin working on them later. As for composition, she sometimes creates sketches and plans in an attempt to evaluate the scale gap between 2D and 3D.

She says miniatures have the power to draw you into their world, allowing you to lose your sense of scale and to commute freely through various dimensions.

'I dissect motifs so that no story can be read.'

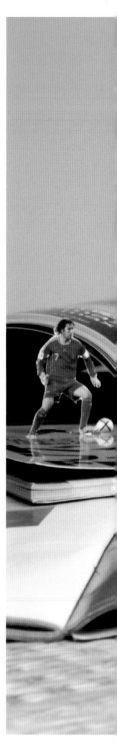

RIGHT
THEIR SITE/YOUR SIGHT
MIXED MEDIA

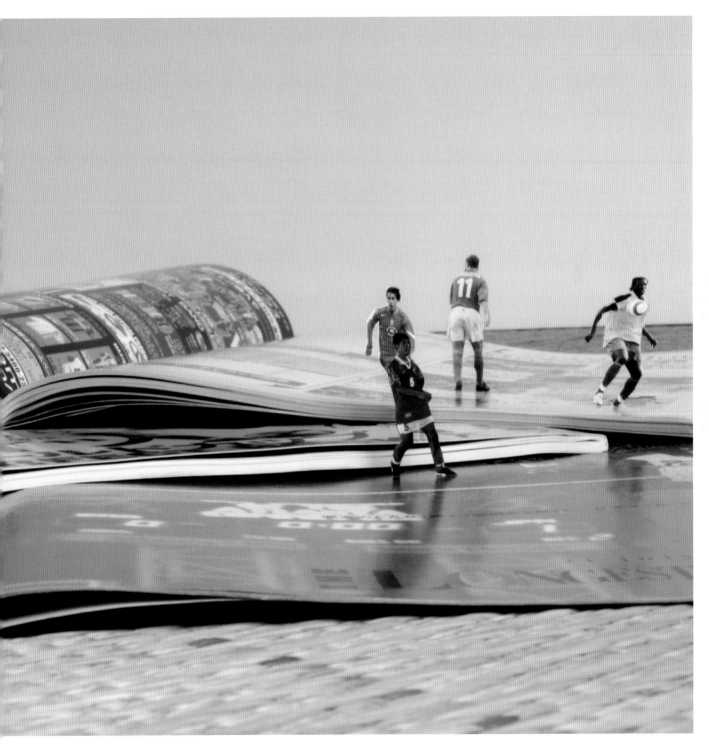

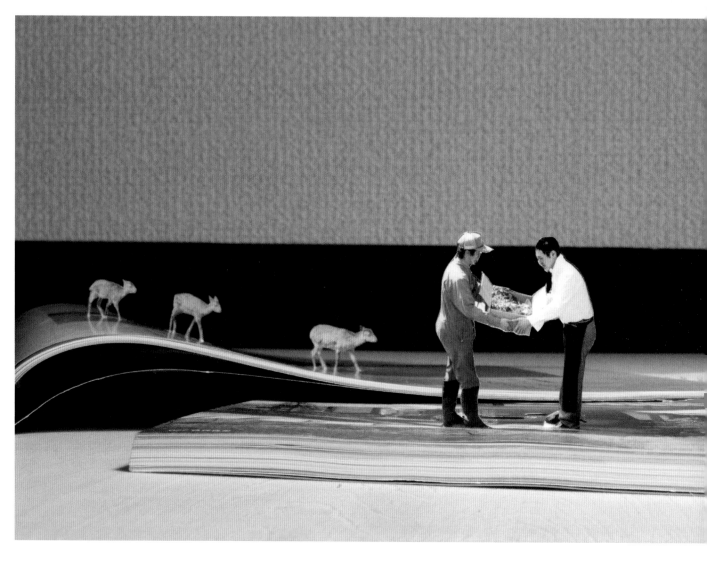

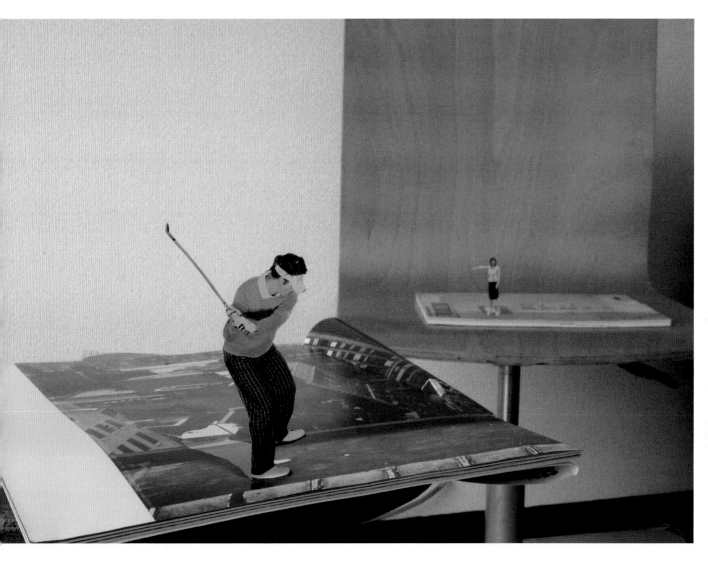

GUY LIMONE

French artist Guy Limone says his work with miniatures is born out of the tension between his passion for conceptual art, his training as a painter and his day job in animation.

He paid for his studies by taking care of children and teenagers on his afternoons off and he started working with miniatures by placing the figurines left behind by the kids in minimalist geometrical settings made out of wood painted in vivid colours. His own teachers saw this as an act of provocation, an attempt to question the seriousness of art, whereas he was really just trying to connect his various interests: art and everyday life, humour and analytical thought, playfulness and precision.

It was when living in Marseille (Limone now lives in Montreuil), that he first became aware of the phenomenon of 'the crowd' and the diversity of mankind. He views the figurines he uses as little sculptures, which allow him to work with social and political concepts. He is particularly attentive to statistics and often uses them to christen his work.

'I tried to represent the world in its present scale: a world saturated with information, with data, numbers, images, networks, over 6 billion human beings...'

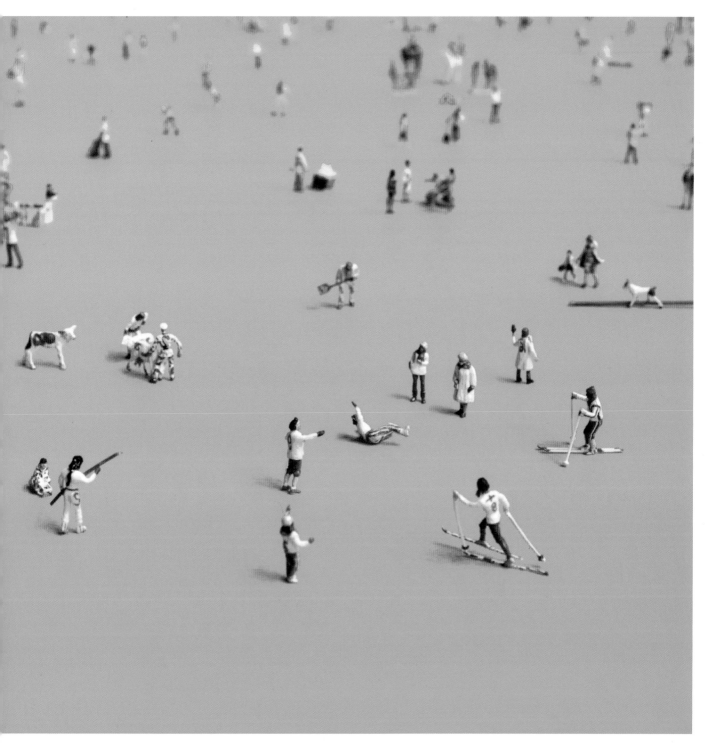

82

RIGHT
<u>WE CONSIDER THAT</u>
<u>DURING THE YEAR 2007</u>
<u>HALF OF THE WORLD</u>
<u>POPULATION BECAME</u>
<u>URBAN</u>
MIXED MEDIA

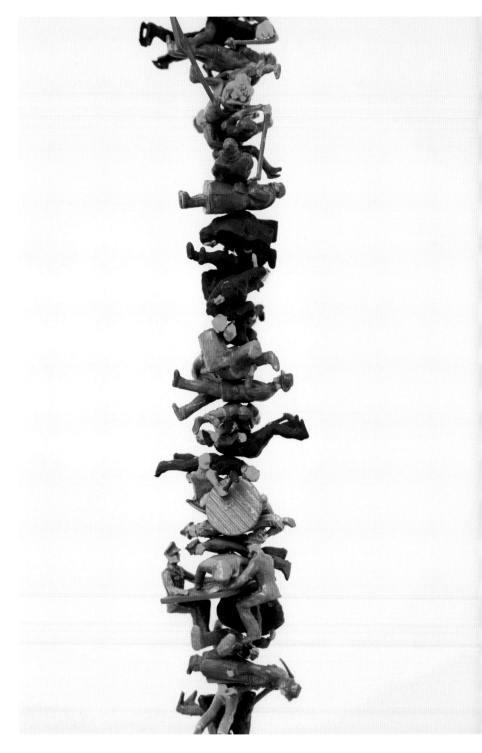

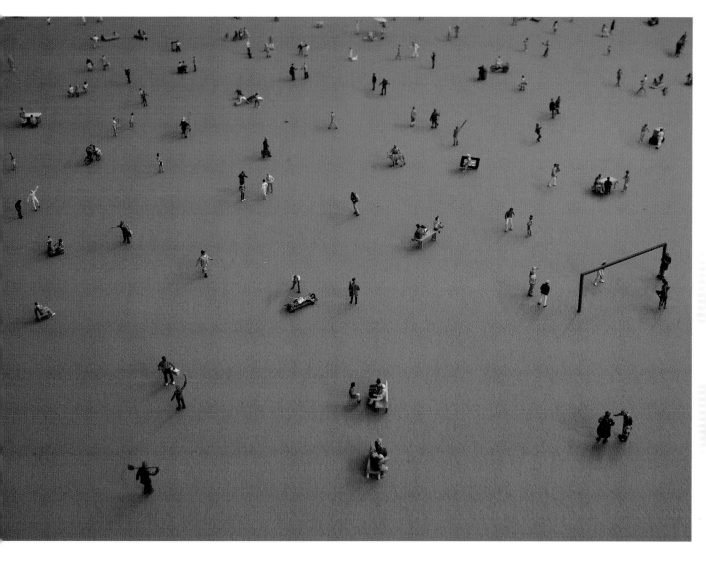

SANTIAGO LORENZO

Spanish artist, filmmaker and writer Santiago Lorenzo believes his boundless love of toys and figurines comes from the fact that he wasn't allowed to play with them as a child. He says the element of 'play' is all important to his work. In fact, he adds, once he has finished a piece of work, the fun is over. After they are made, some of the pieces make him want to bombard them with firecrackers and marbles in order to see them explode. Up until that point, making them is wonderful. He compares the process to being an architect without having to spend seven horrible years studying equations and integrals, or a general in a battle without victims.

He seems to practise a form of reverse commuting and goes to produce his work – which he describes as 'junk, model-in-the-middle-of-the-muddle, clutterings, Kit-kats, artifactual furnitoys' – in a country house in a village of about ten inhabitants. He says that, for him, arriving at this micro-village is just as amazing as it was to arrive in a capital city of millions of inhabitants, back when he first came to Madrid.

Lorenzo says the process of experiencing miniatures starts with a sense of dèjá-vu, sending you back to the one country we have all passed through: childhood. He also talks about the sensation of flying, which we still haven't interiorized enough for it to seem normal. He describes it as a fantastic sensation of having wide areas of space on view. Secretly, he also delights in the idea that he can destroy a block of houses with one kick. Finally, he says, it is highly possible that this love for miniatures (so manageable, so fragile) has something to do with an inferiority complex.

'First, the idea comes to you in the street, generally as a result of a misunderstanding. Then, bored at home one day, you pick up a pencil and you let it run about, just like you do with your dog in the park.'

RIGHT
MUEBLE FEMINIMORFO
FURNITURE
MIXED MEDIA

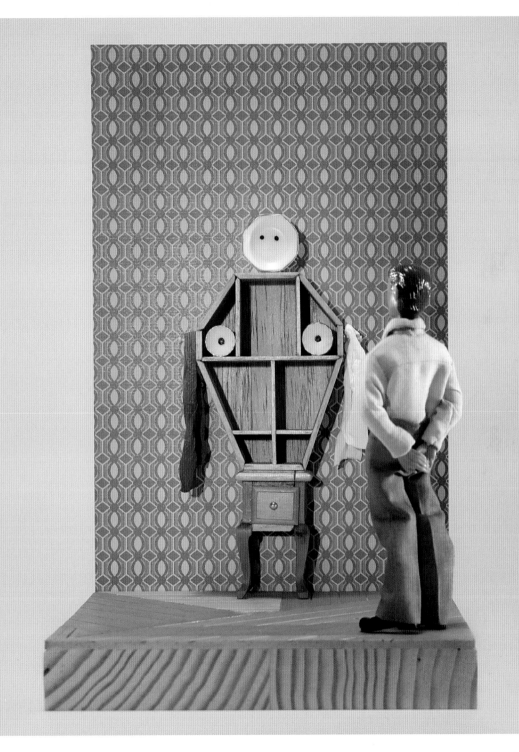

RIGHT
MUEBLE-BAR SECRETO/
SECRET COCKTAIL CABINET
MIXED MEDIA

BELOW
MUEBLE-BAR SECRETO/
SECRET COCKTAIL CABINET
MIXED MEDIA

FAR RIGHT
BUHARDILLA AL REVÉS/
ATTIC UPSIDE DOWN
MIXED MEDIA

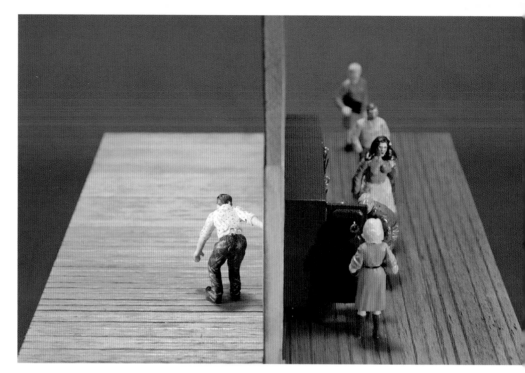

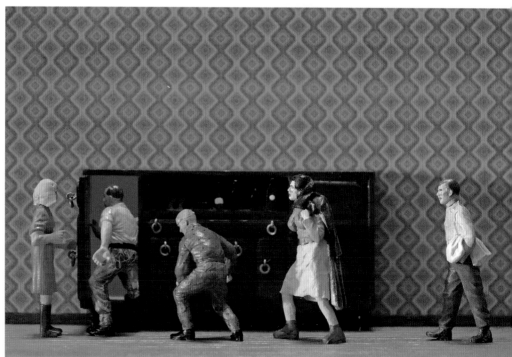

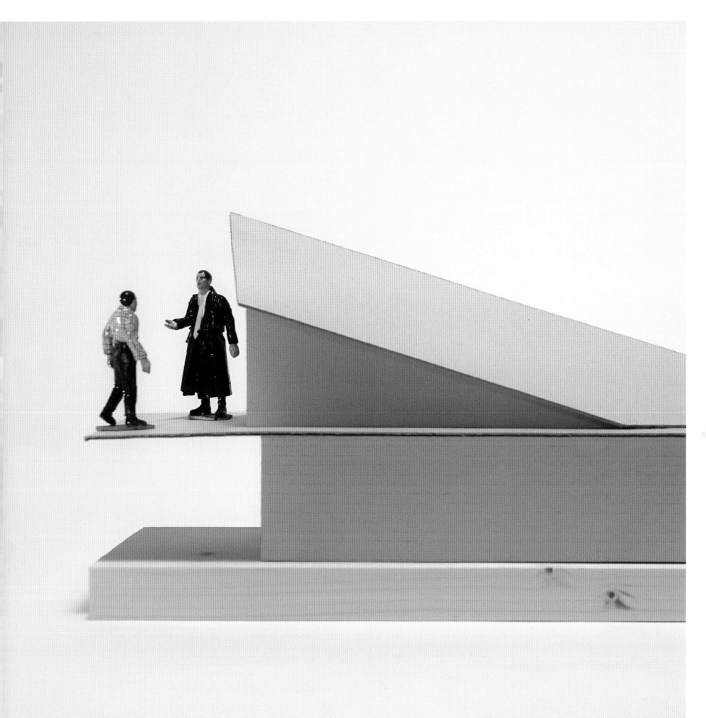

MINIMIAM
(AKIKO IDA & PIERRE JAVELLE)

Minimiam is the pen/camera name of renowned and prolific food photographers Akiko Ida and Pierre Javelle, who met when studying photography at the Paris École Nationale Supérieure des Arts Décoratifs.

One key aspect of their work is the use of macro-photography, which constrains them to work with extremely short depths of field and very small apertures. Another is the figurines (made by German companies that supply the model railway market), which allow them to transmit a direct vision of the action. The figures' attitudes are clear, but the context makes them ambiguous. The small size of the characters makes the surrounding space gigantic and architectural, and the image framing situates us in a landscape where the eye can evolve, examine, stroll.

'When I was 4 or 5 years old, I started to draw small people and animals living in the food (in the fruits, vegetables, breads, sweets, etc.). I've created many stories in this miniaturized world.' (Akiko Ida)

By highlighting the texture and detail of the photographed object, Ida and Javelle aim to make people re-discover the objects, which are often quite ordinary, and almost always edible. When asked about their attitude to miniaturization, they reply, 'But we are magnifying food!' They have worked with a large number of food publications and feel much closer to the culinary than the art world.

Ida and Javelle are both very patient. You have to be, they say, when you are obliged to stick figures on a melting ice cream at least 15 times in the middle of summer…

RIGHT
NID DE POULE
DIGITAL COLOUR PRINT

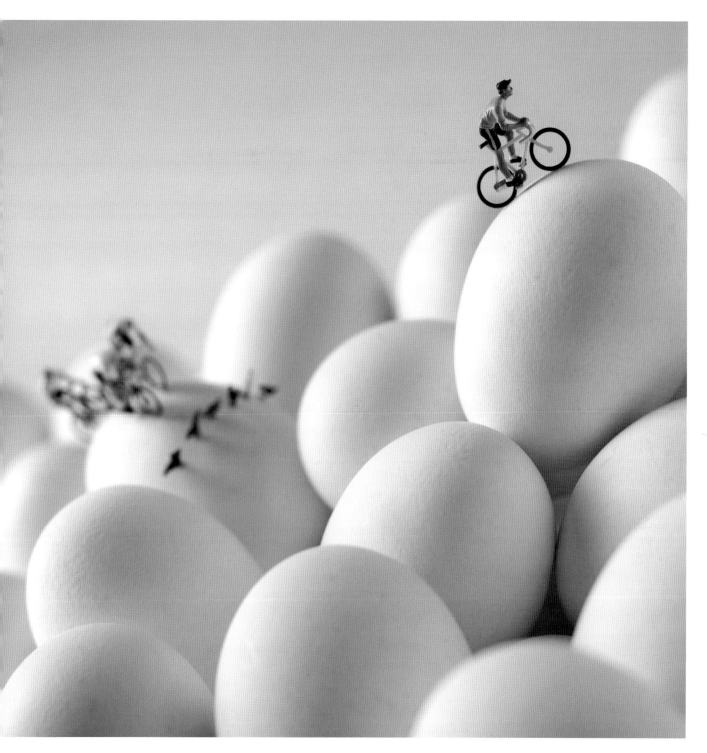

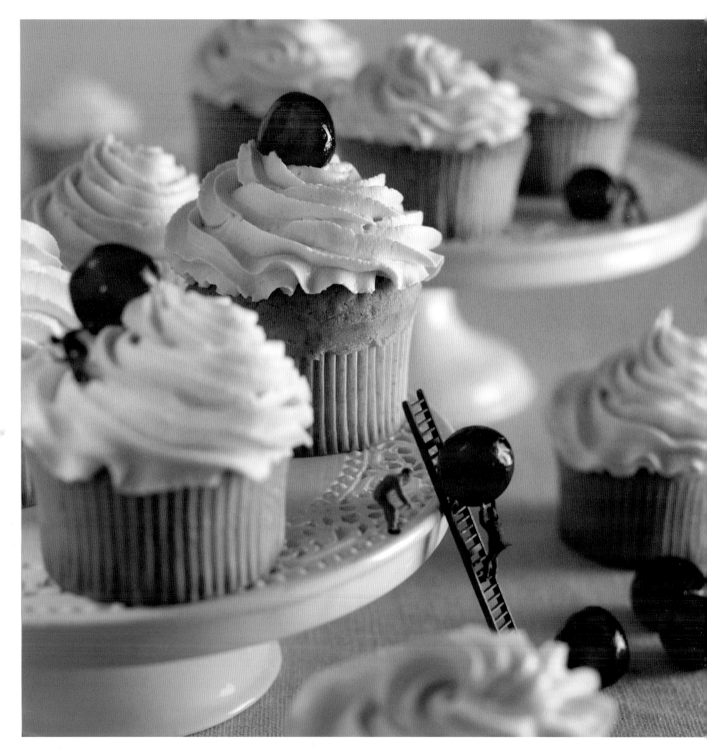

LEFT
CUP CAKE & CIE
DIGITAL COLOUR PRINT

BELOW LEFT
LITTLE RED BROCCOLI
DIGITAL COLOUR PRINT

BELOW RIGHT
THE TUB
DIGITAL COLOUR PRINT

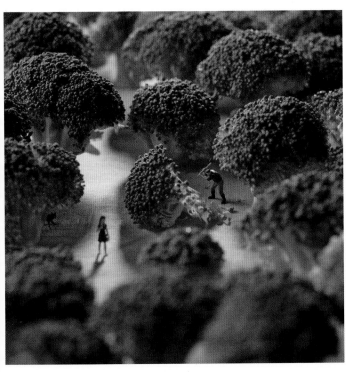

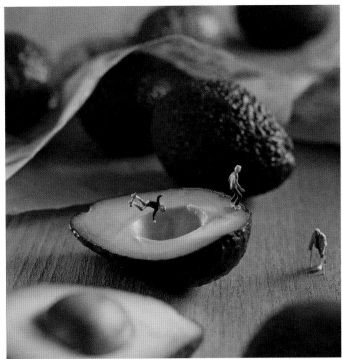

BELOW LEFT AND RIGHT
NINJA MAKI
DIGITAL COLOUR PRINT

FAR RIGHT
SWEET STORM
DIGITAL COLOUR PRINT

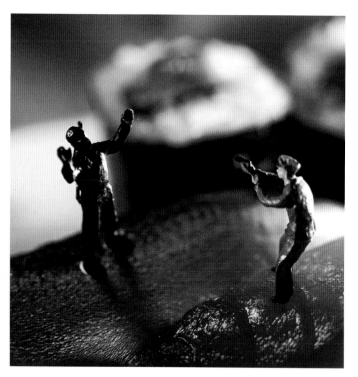

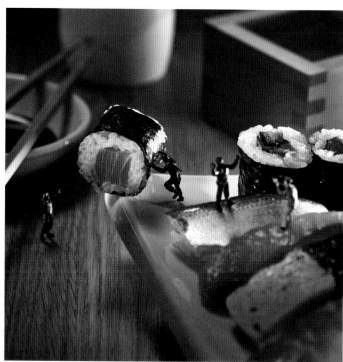

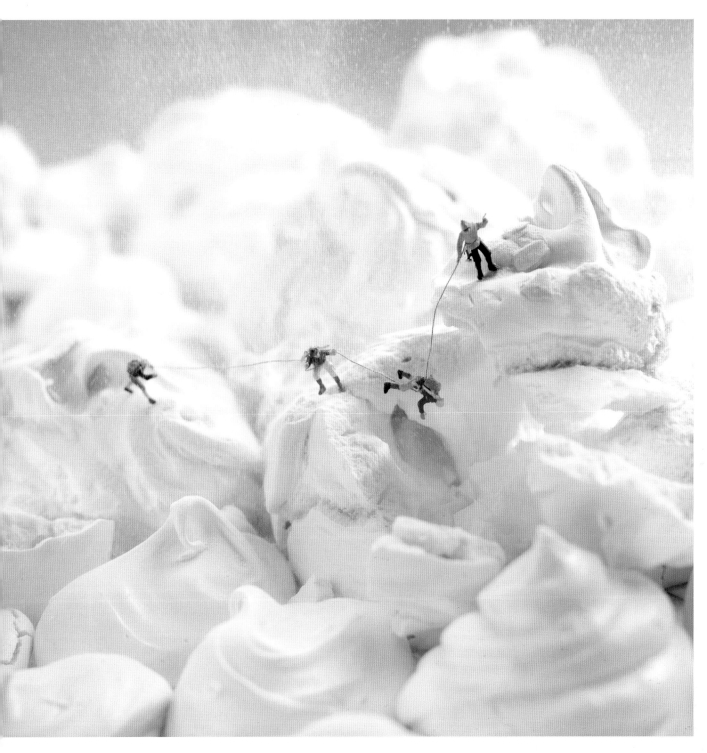

LILIANA PORTER

Fine artist Liliana Porter first worked with a miniature scene in the eighties. It was a tiny sailboat on top of a small shelf. There was also a miniature figure of a traveller, which has become a recurrent subject in her work: the small traveller in an enormous, infinite space, trying to find his or her way home.

Porter casts characters and props from sets of toys and figurines that she finds in flea markets, antique stores and other odd places. The objects have a double existence. On the one hand, they are mere decoration, insubstantial ornaments, but, at the same time, they have a gaze that can be animated by the viewer, who endows the objects with interiority and identity.

The choice of space and scale are subjective decisions, she says, and in her work the empty space is almost a protagonist. It serves as a sort of silence that isolates the object (or figurine) and prepares the viewer to relate more directly to what is in front of him or her. She intends to create an abstract place where there is no present or past and where the concept of linear time does not exist.

'These "theatrical vignettes" are constructed as visual comments that speak of the human condition. I am interested in the simultaneity of humour and distress, banality and the possibility of meaning.'

In Porter's sculptures, a person is generally confronted with a task that is out of scale. This functions as a metaphor about the human condition, as well as creating an increased awareness of the distance between the universe and us, or between what we know and what we ignore.

ABOVE RIGHT
BLUE BIRD
WALL INSTALLATION

RIGHT
FORCED LABOR (STONE)
WALL INSTALLATION

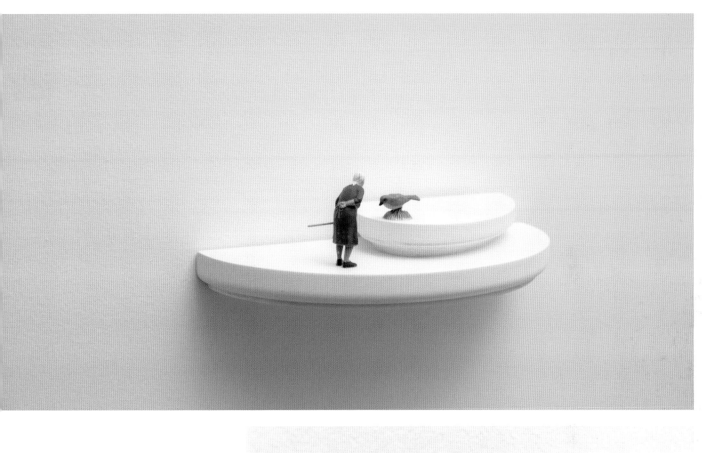

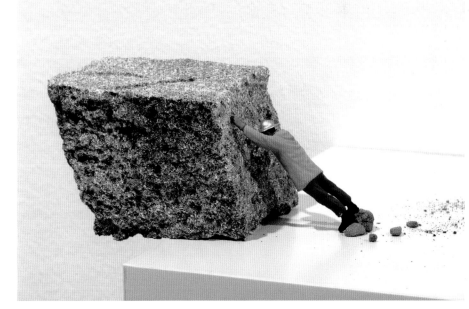

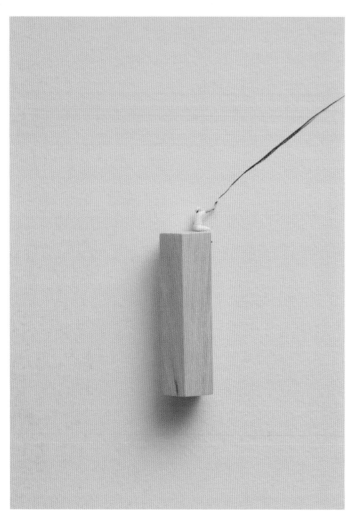

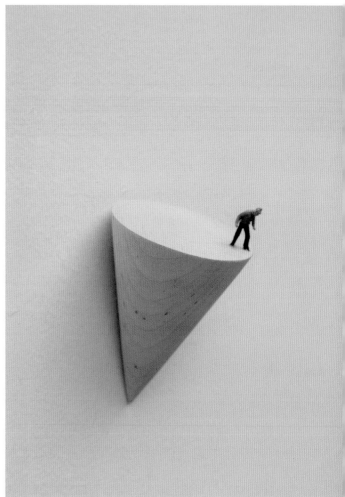

ABOVE LEFT
PAINTER (DRESSED
IN WHITE)
WALL INSTALLATION

ABOVE RIGHT
LIMIT
WALL INSTALLATION

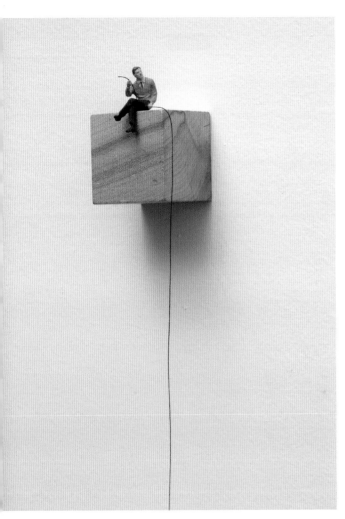

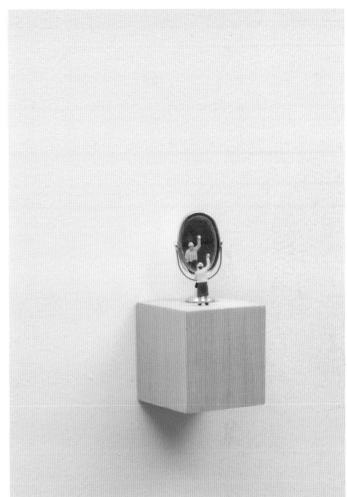

ABOVE LEFT
<u>MAN WITH STRING</u>
WALL INSTALLATION

ABOVE RIGHT
<u>MIRROR</u>
WALL INSTALLATION

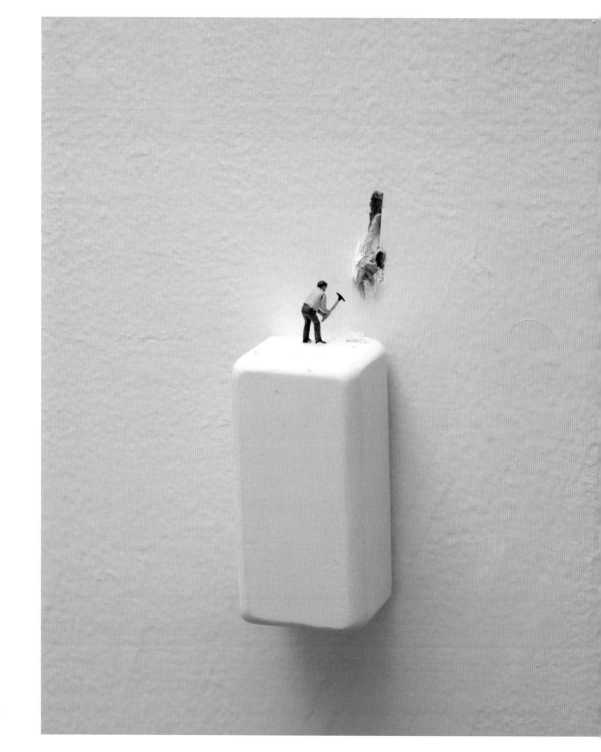

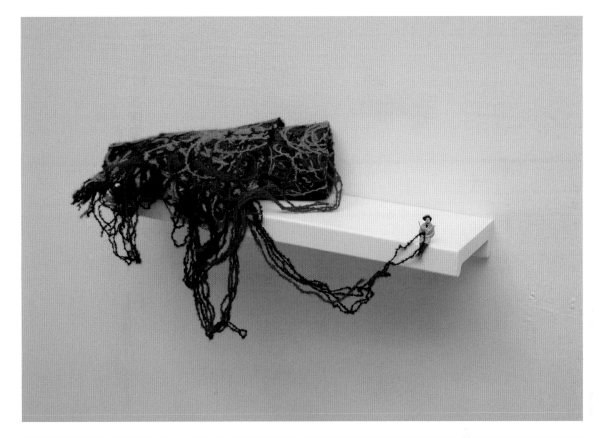

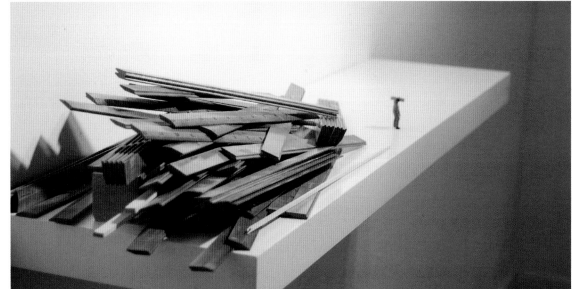

ABOVE RIGHT
<u>WEAVER (WITH HAT)</u>
WALL INSTALLATION

RIGHT
<u>FORCED LABOR</u>
<u>(LUMBERMAN)</u>
WALL INSTALLATION

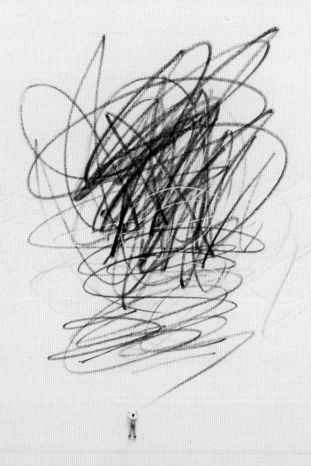

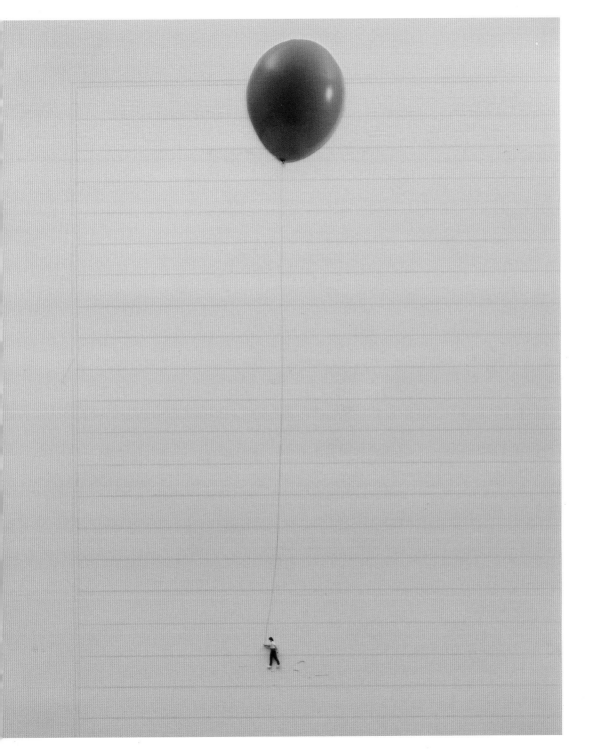

THE RAINBOW-MONKEY

The Rainbowmonkey was born in the Bavarian town of Augsburg. He trained as a draughtsman in the textile industry, then studied communication design. After a few years of nerve-racking agency work he decided to leave for New Zealand, where he started again from scratch, developing his skills as a designer, artist and musician.

Coming from a computer-based field (graphic design), The Rainbowmonkey tends to enjoy developing work in an analogue manner, with less digital manipulation and more real-life impact. However, the *Islands* piece featured here actually started off as an idea for a digital 3D project (*There we go!*).

It is difficult not to connect *Islands* with the move to New Zealand, but the artist says the main inspiration was visual: to create a beautiful illustration of the side view of an iceberg floating in water. It shows the massive discrepancy in the volume of what is hiding underwater and the small visible island above the surface. The islands are hung from the ceiling by transparent strings, floating in the room at roughly eye level. The audience has to come really close to see everything, while being careful not to hit any of the islands. The viewers enter a fragile world where they are the giants: superior, yet helpless.

'I liked the idea of something isolated, drifting randomly through space. Our own personal lives seem to behave identically, just floating through a sea of tasks, problems, joys and adventures – often uncontrollable.'

RIGHT
CONSPIRACY
INSTALLATION

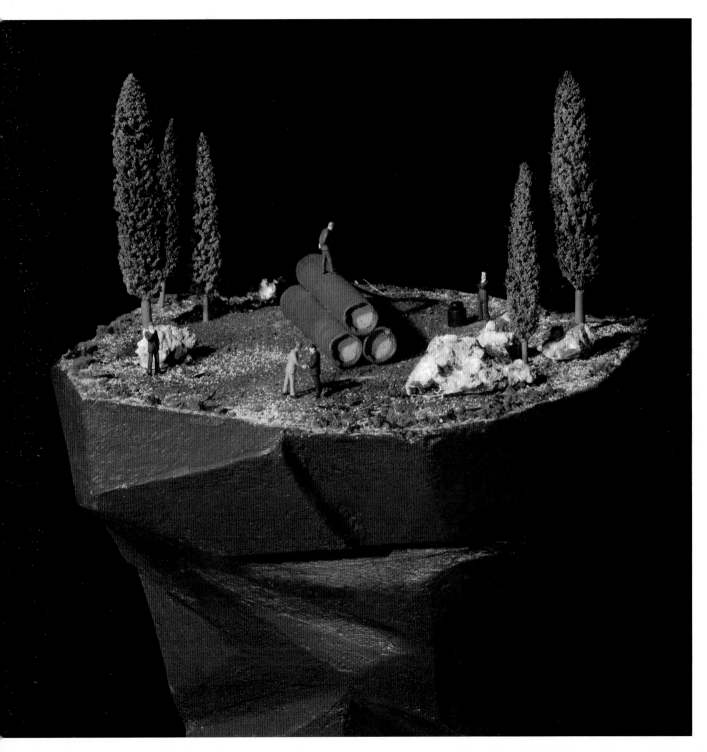

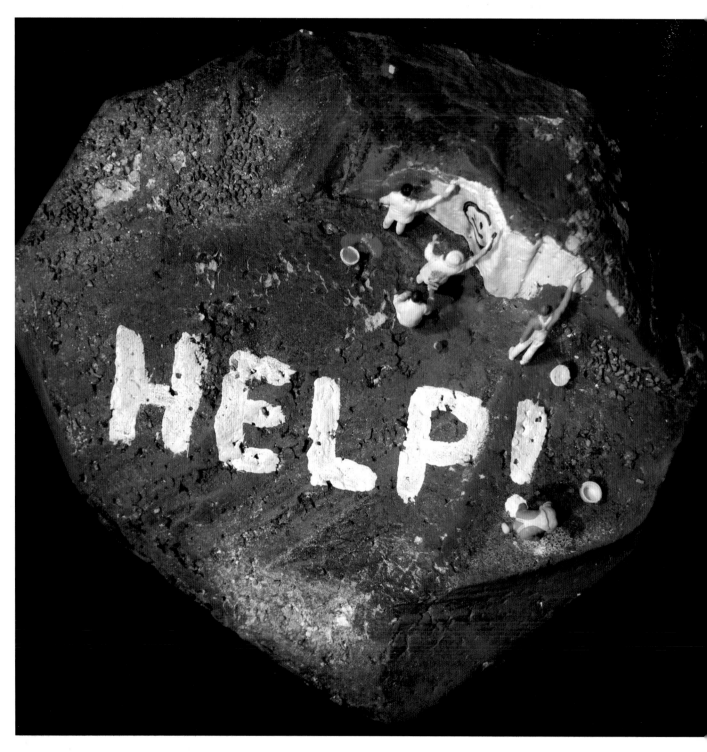

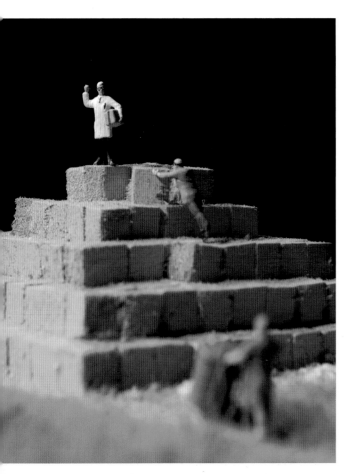

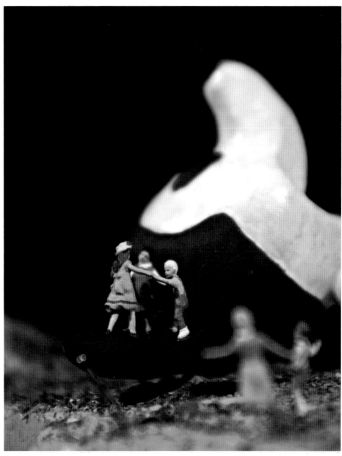

JONAH
SAMSON

Jonah Samson combines his career as an art-ist with his day job as a doctor. Medicine helps him put things in perspective, 'I remember the Dean of my medical school saying that she liked to make pottery, because if some-thing went horribly wrong, nobody died.'

One of the things he loves most about min-iatures is that he gets to control every aspect from the ground up, although there's a lot of trial and error involved. He spends a con-siderable amount of time trying to make a river look like it's flowing, or trying to make a 1:87-size penis. Sometimes it's a disaster and at other times it all comes together by accident. He has learnt how to do things more efficiently and is pretty patient when putting the sets together. 'It helps that I know how to treat all the injuries I get from using glue guns and Xacto knives...' But even if there is a disaster, at least no one's dead.

Samson is fascinated by how people react to seeing toys acting out adult situations. We're surrounded by and are quite used to images of sex and violence, but miniatures take our responses even further into that realm of fantasy. People often laugh when they see his pictures, but, he says, he is sure their reac-tions would be very different if he were using real people in real spaces.

'Much of my medical work involves people with psychiatric problems and addiction. It's nice to be able to make art that is dark or unsettling, but still whimsical or comical.'

RIGHT
FLASHER
(FROM THE SERIES
PLEASANTVILLE),
CHROMOGENIC PRINT

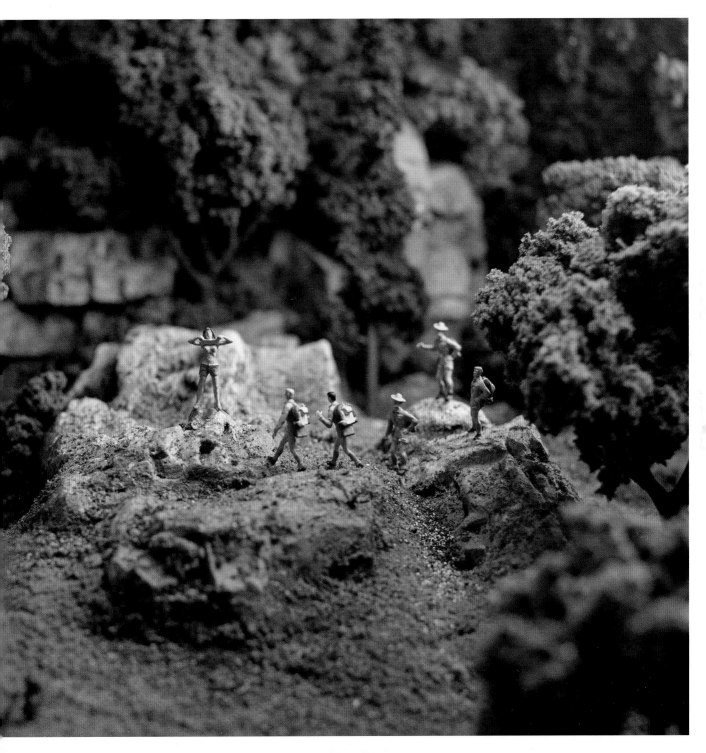

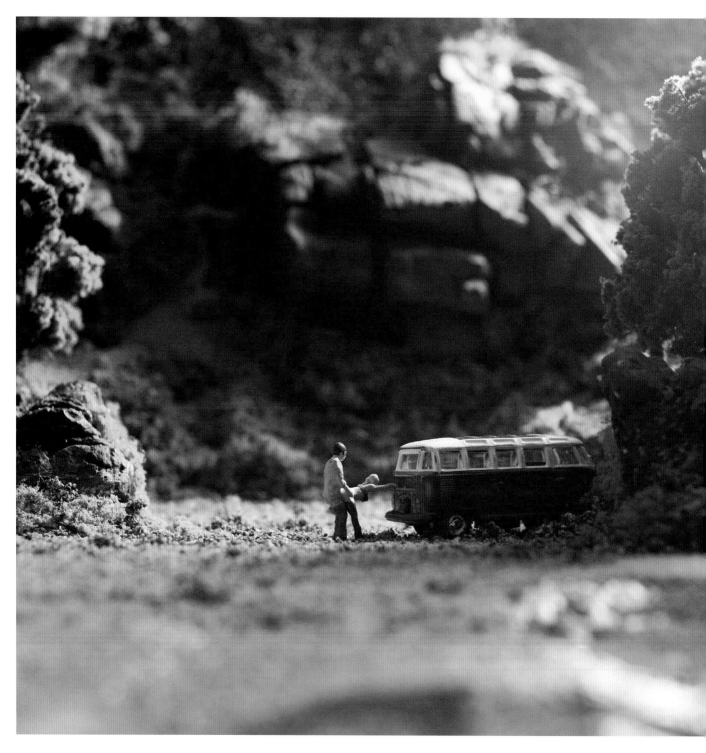

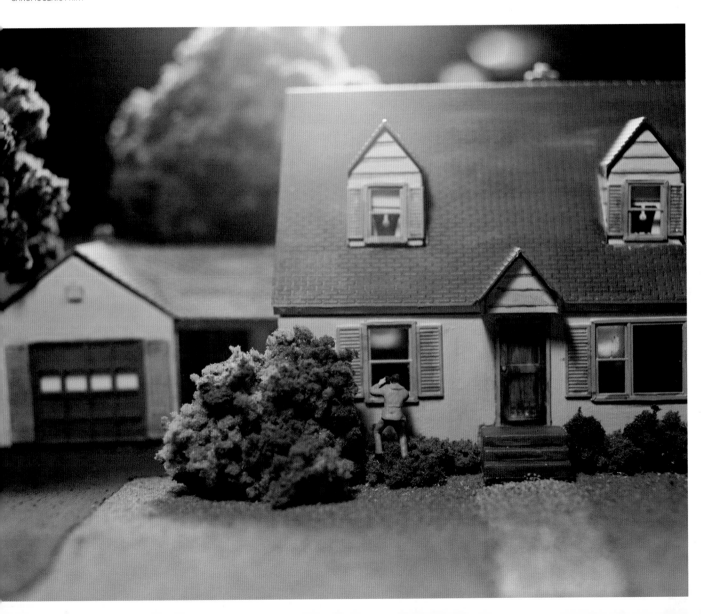

110

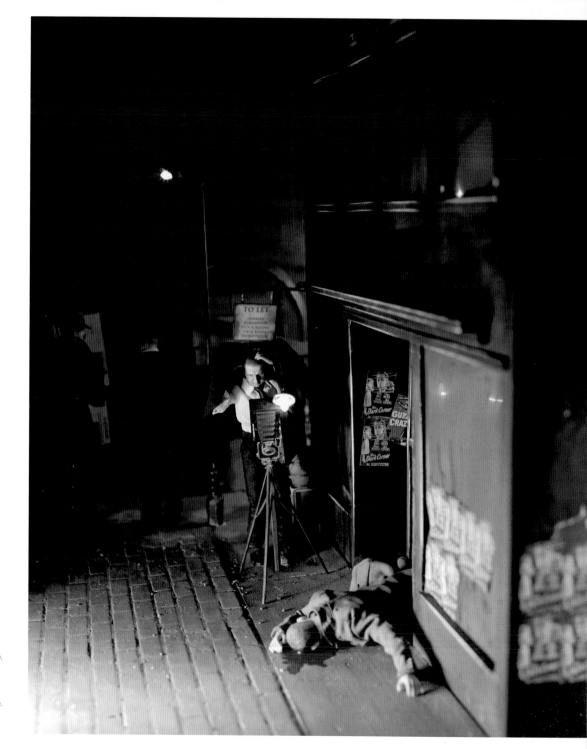

RIGHT
CRIME PHOTOGRAPHER
(FROM THE SERIES *NOIR*),
CHROMOGENIC PRINT

FAR RIGHT
APARTMENT 14K
(FROM THE SERIES *NOIR*),
CHROMOGENIC PRINT

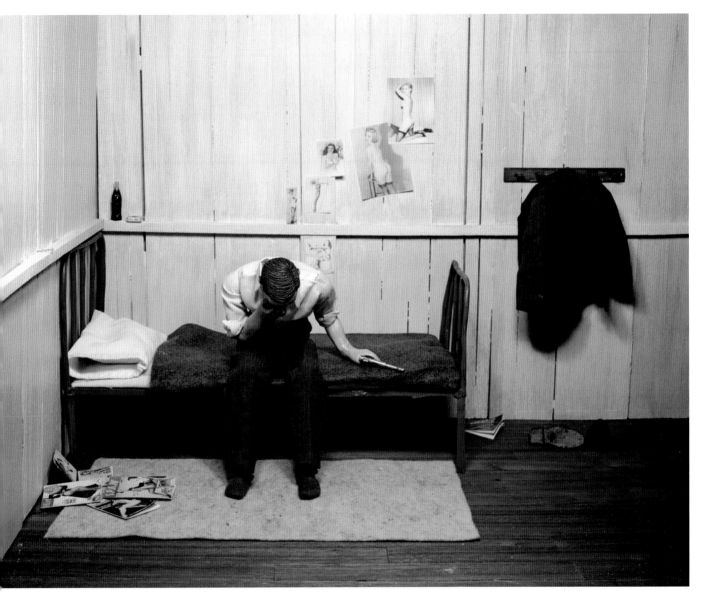

LISA
SWERLING

Through her *Glass Cathedral* series, Lisa Swerling wants to share the experience of finding something precious and making it a part of life. Whether this is through hunting at car boot sales, searching in seaweed for tiny shells, unpicking a vintage dress and keeping the sequins in a jar on the window-sill – there is a common thread of delight in discovery, and the joy of assimilating an object into life.

One collector described her work as, 'brilliant tiny worlds, each making their own small statement on this complicated world we live in'. Her work explores the scope and diversity of human endeavour, from a passion for cleanliness to a desire to create something special and meaningful with one's life, or our ability to feel safe and comforted despite massive uncertainty and danger.

These are perfectly self-contained worlds. The figures own their space, but there is also a sense of infinity in the scale. Each of them suggests the possibility of a parallel reality. The viewer's experience of the piece, the giant eye peering in from outside, is part of the effect. These monstrous eyes emphasize the vulnerability of the little people within the box.

According to the artist, the worst crime the figurines can commit is to leap from her grasp and disappear into a crack in the floorboards. There must be whole colonies of them under her floorboards, possibly planning a revolution.

'My daughters don't mind in the least me rampaging around with pots of glitter and glue and tiny little people while they do their thing. It's parallel play.'

RIGHT
PARTY PEOPLE
ARTBOX

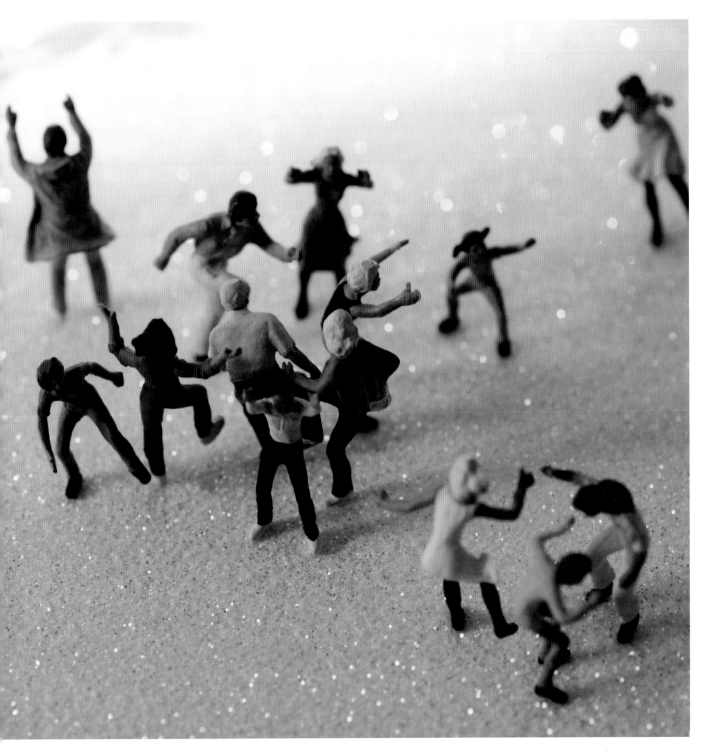

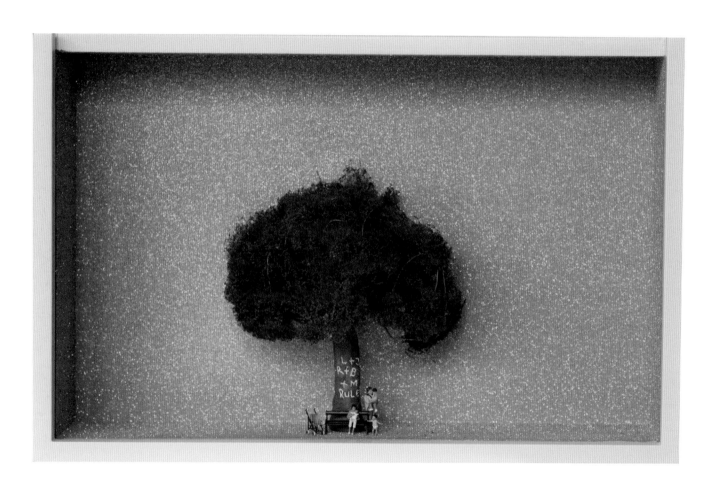

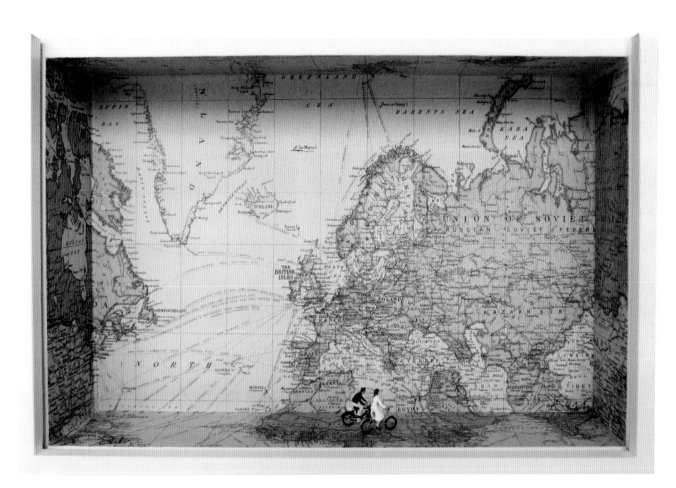

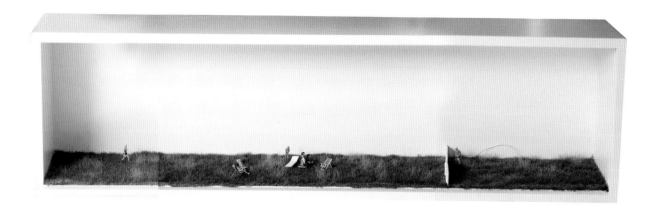

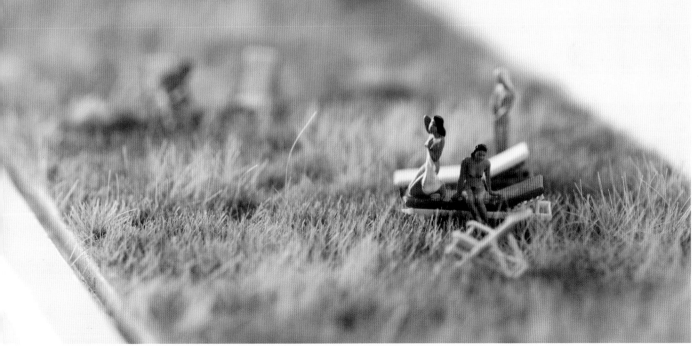

HEMA UPADHYAY

Visual artist Hema Upadhyay was brought up in the Baroda region in India. She now lives in Mumbai, a city that greatly influences her work. She says the city was just too difficult to grasp at first; she felt like an alien in an often hostile environment. The contrast between her own scale and that of the megalopolis spreading all around her was very stark. She used to live in high-rises and when she looked down human beings were just like tiny miniatures.

The narrative in her work is often autobiographical. Upadhyay says it is about constructing the self as a gradual process. This self confronts personal phobias and shortcomings and is confronted with realities such as identities, public and private spaces, divisions of class, caste, religion and gender.

She uses the language of realism in her work. *Dream a wish wish a dream* is first of all a reconstruction of the slums of Bombay, seen from the air. It is built with thin aluminium metal sheets and car scrap. It deals with the socio-political situation of Bombay, but also commemorates the wishes, dreams and aspirations lived (and, she says, 'unlived') in these small cities within a city.

'In my old house we had this huge wooden staircase and after the rains suddenly I saw a mushroom looking like an umbrella spring up in the corner of one of the stairs and I remember that I sat the whole day watching that mushroom, thinking "now a fairy will come and sit on it, now a fairy will come and sit on it".'

RIGHT
DREAM A WISH
WISH A DREAM
MIXED MEDIA

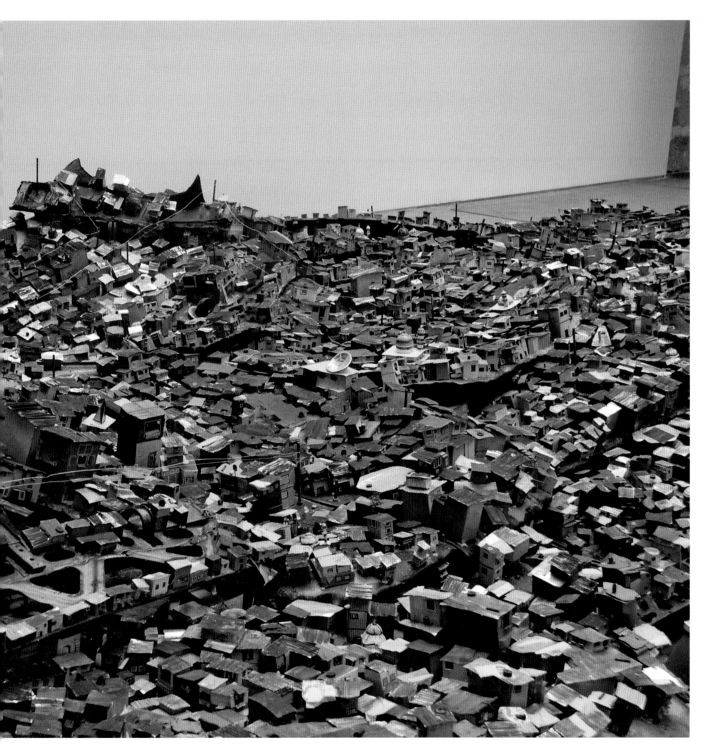

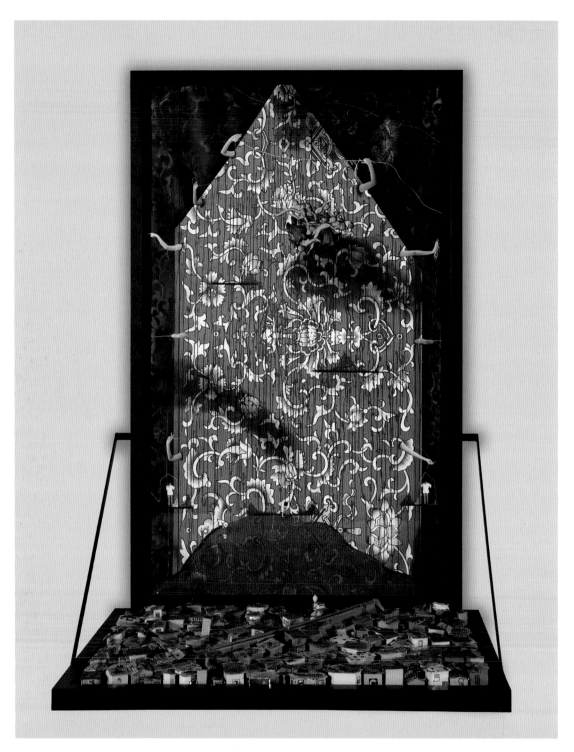

LEFT
KILLING SITE
MIXED MEDIA

RIGHT
THINK LEFT, THINK RIGHT,
THINK LOW, THINK TIGHT
MIXED MEDIA

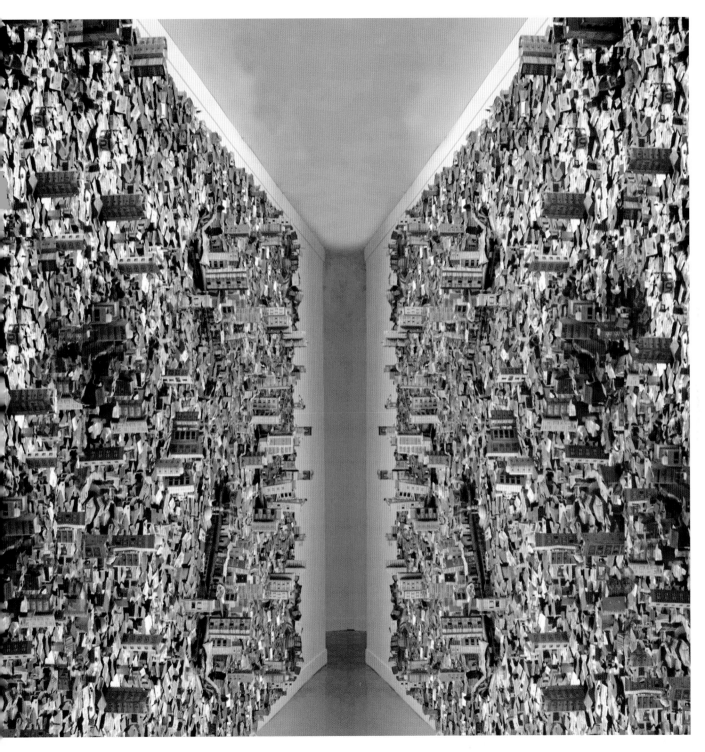

PAOLO VENTURA

Italian artist and photographer Paolo Ventura likens the table he uses to build sets to a painter's canvas. In fact, he begins his set-ups with highly accomplished sketches, which are reproduced on a miniaturized scale, starting with the buildings and then bringing in the characters. He makes abundant use of Polaroid pictures (which are amazing in themselves) all through the process, contemplating them until he is happy with a certain scene and can start shooting. The artist also likes to insert two-dimensional and trompe-l'oeil elements such as posters or painted backdrops in his sets. He likes the fact that this makes the viewer think, 'Oh, yes, this is an optical trick. Therefore the rest of it must be real…'

His stories are based in cities in the north of Italy. He refers to them as, 'Winter cities, even in the summer these are winter cities.

'I like the idea that in the last minutes before you die you see a film of your life.'

The colours are winter colours. When I think of my childhood, I think of the winter.' He says winter is the season when people go out on their own and really strange and special things happen. His stories tend to be set at the edges of cities, just before they turn into the countryside, 'A no man's land between the end of the city and the beginning of something else.' These are also usually the areas where circuses set up camp.

Ventura mentions the 1920s painter Antonio Donghi as a key figure of inspiration, both in terms of the atmospheres he creates and also his characters (some of which relate to the circus, one of Ventura's principal themes).

He refers to the way the painter treats light and the monochromatic palette of colours he uses.

It is easy to guess from the sadness and nostalgia that pervade, that Ventura's work is closely related to a sense of a personal past. The artist mentions his childhood, his dreams and those moments of boredom when, as a kid, he would look around not knowing what to do next. He says this is still often the way he gets started on a project as an adult.

RIGHT
WINTER STORIES #54
(THE BALLOON SELLER)
DIGITAL C-PRINT

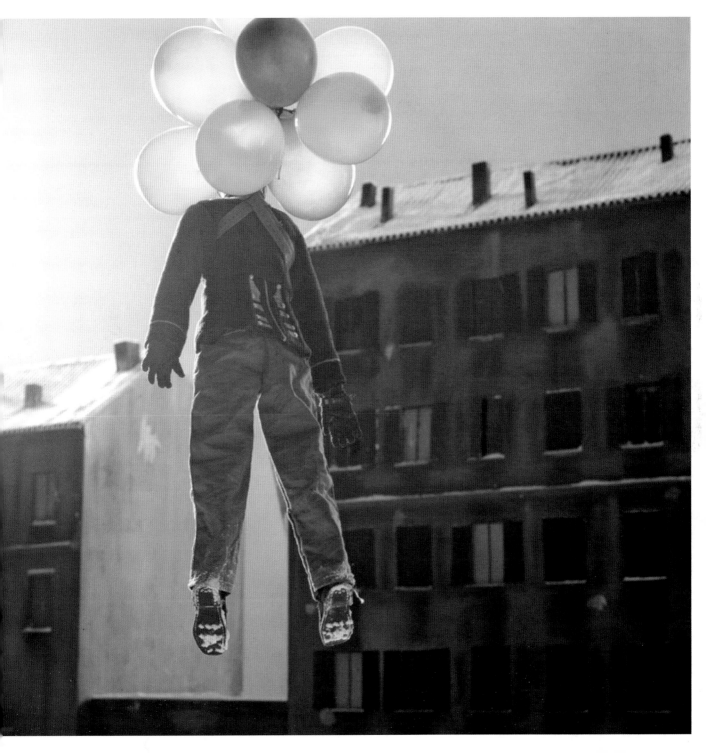

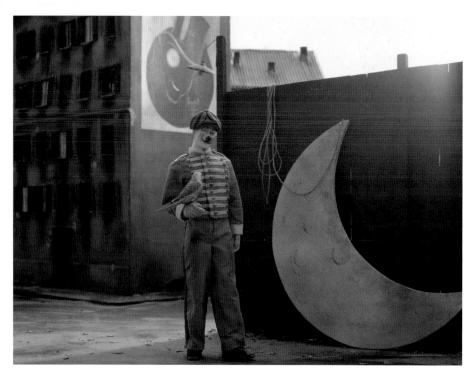

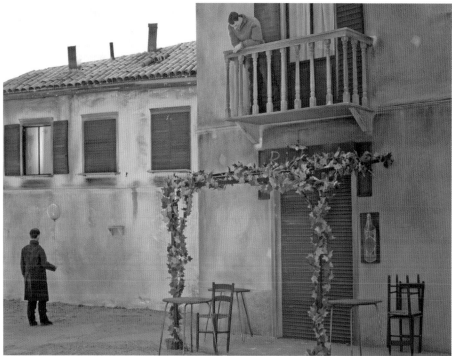

ABOVE LEFT
WINTER STORIES #60
(THE CLOWN, THE MOON
AND THE PARROT)
DIGITAL C-PRINT

LEFT
WINTER STORIES #56
(SATURDAY)
DIGITAL C-PRINT

RIGHT
WINTER STORIES #55
(THE SWARD SWALLOWER)
DIGITAL C-PRINT

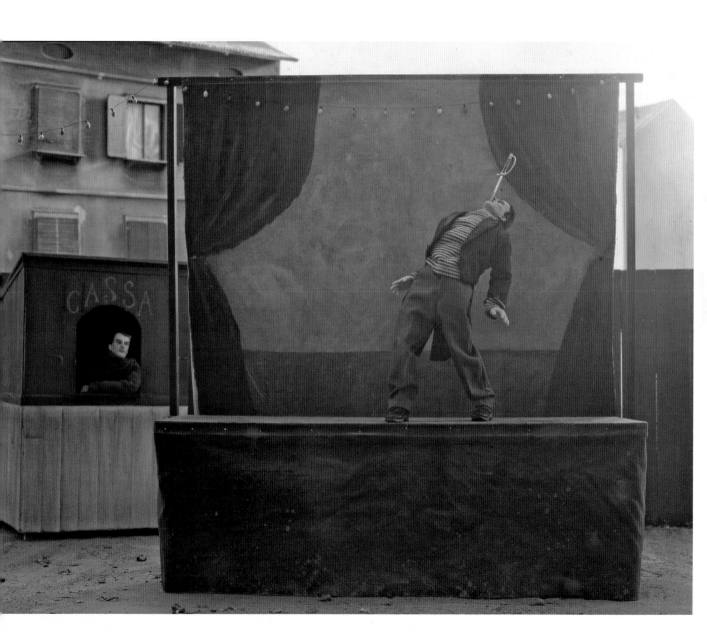

BELOW LEFT
WINTER STORIES #49
(THE STILT WALKER)
DIGITAL C-PRINT

BELOW RIGHT
WINTER STORIES #19
(FULL MOON)
DIGITAL C-PRINT

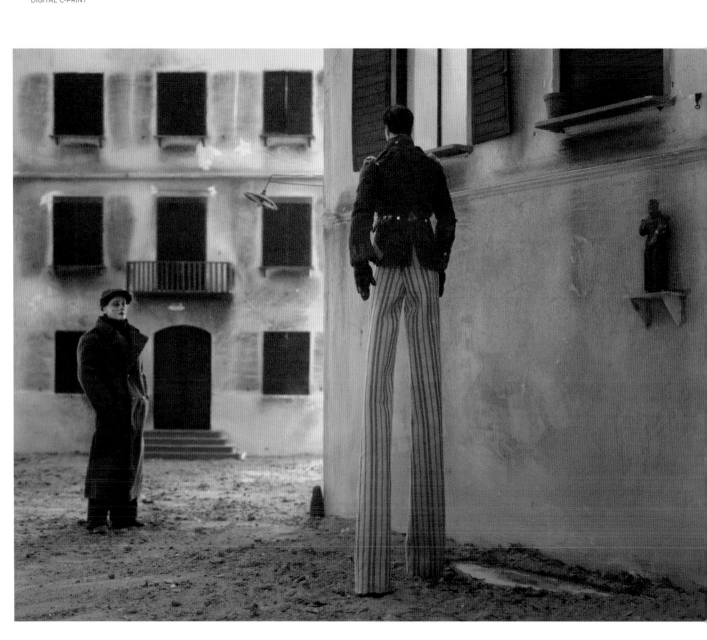

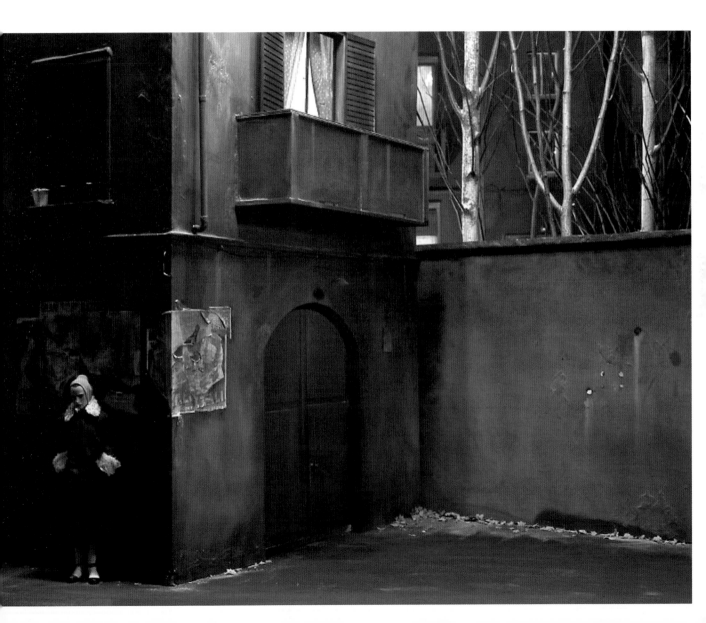

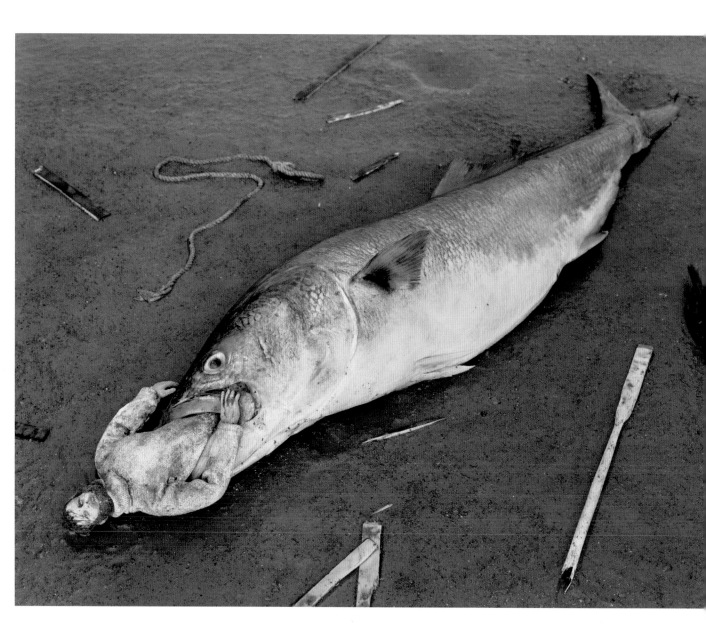

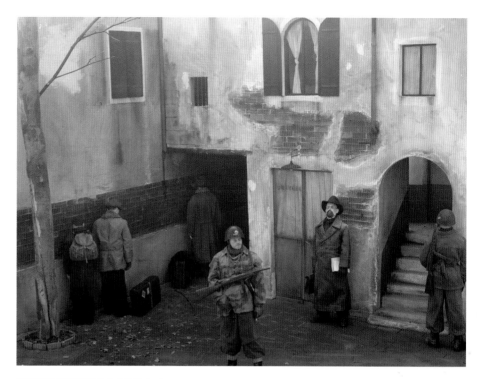

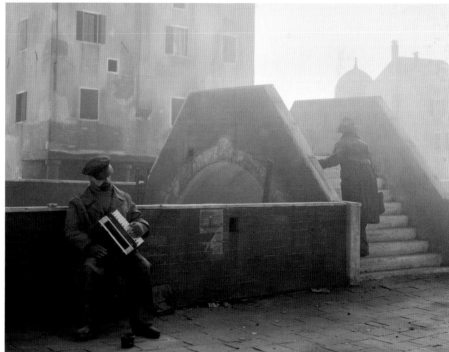

GRAEME WEBB

Graeme Webb's introduction to the photographic industry was as an apprentice colour printer for a London society photographer. In recent years, he has worked in film and video post-production. After some exposure to stop-motion animation (he lists Eastern European stop-motion as a major influence), he returned to still photography in 2009 and started to experiment with dioramas and models. Initially he worked with a pinhole camera and then, as the models became more sophisticated, he moved to a digital camera.

Playing as a child in the bomb-damaged areas of south London in the late 1950s and 60s was highly formative for Webb. A lot of the sets he creates are partially remembered scenes from his childhood. The little figures that populate the scenes always look hopeful, considering the ruined environments they find themselves in. The photographer feels that the modelling process is particularly therapeutic. The models are quite frail and don't really have a life outside of the photographs. These are fragile existences.

'If I stand in the shadow of the new "Shard" building at London Bridge, I feel very small.'

RIGHT
BLEAK HOUSE (SERIES)
DIGITAL PHOTOGRAPH

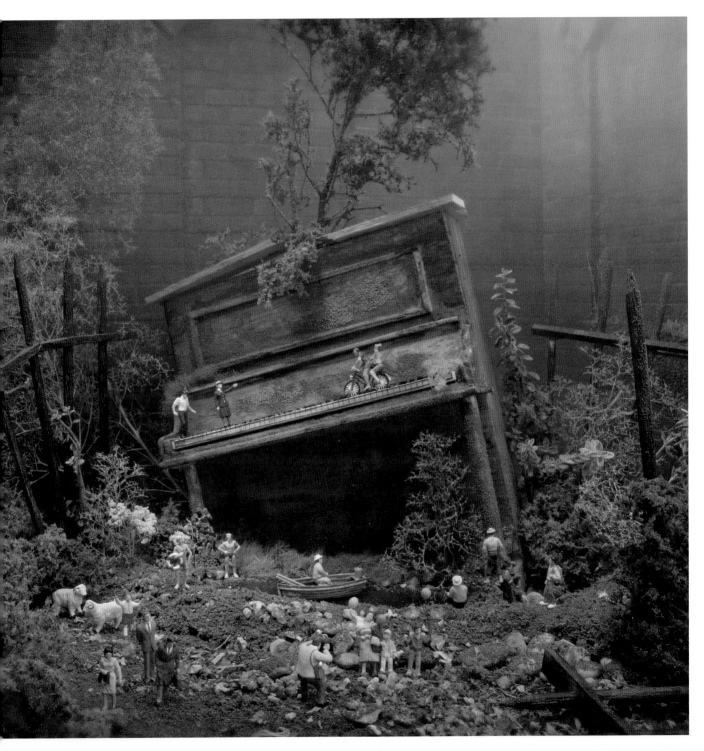

GRACE
WESTON

Grace Weston remembers once seeing an enormous industrial hangar in the distance, back when she was still seeking curious and unusual locations out in the world to photograph. She drove towards it, parked her car and walked up to the huge doors, which were closed but had cracks wide enough to see through. She leaned in and looked, and nearly fell back in a panic attack. Inside, facing her, was the nose of a gigantic blimp. She had discovered a facility that repaired them. She feels blimps have a frightening, eerie and beautiful quality to them, which she tries to recapture in her work – but going about it the other way round.

Weston built her first serious miniaturized scene in her studio in 1997. It immediately appealed to her, because she did not have to find live models and create large expensive sets, or hire assistants. She could manage and control it all on her own and take as much time as she wanted to get it just right.

Often a prop will inspire her, or she will pick a central character for an image. The scale of the prop or character dictates the overall scale. 'My sets look completely different without the lighting and the camera focus I apply. Without that there is no magic at all.'

'Everything is held together with spit and glue, just to create a temporary illusion that I capture with the camera.'

ABOVE LEFT
TORN BETWEEN TWO
LOVERS
FUJI CRYSTAL ARCHIVE
C-PRINT

ABOVE RIGHT
BABY MAKES THREE
FUJI CRYSTAL ARCHIVE
C-PRINT

RIGHT
WINTER WISH,
WINTER DREAM
FUJI CRYSTAL ARCHIVE
C-PRINT

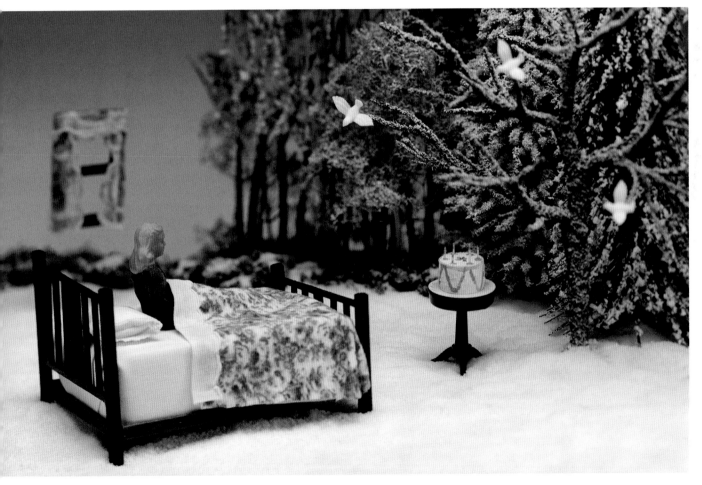

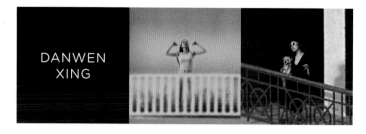

DANWEN XING

Danwen Xing started studying painting as a teenager in the professional art school affiliated to Xi'an Academy of Fine Arts in her hometown of Xi'an (also the home of the Terracotta Army) in the eighties. She then encountered photography and was immediately drawn to the medium. There was no photography education in art schools in China at that time, so she was self-taught. Xing was one of a few artists in late eighties and nineties China exploring the boundaries of photography and using photography as an art form. Through the camera, she observed and challenged the questions from an older Chinese society, female identity and generation issues from the 1960s in China.

In 1998, she went to New York and, on her return to China, she felt greatly stimulated by the traumatic changes happening in the country. In large cities in China almost no area was left unchanged. The rapid changes have completely reshaped the urban landscape and globalization has blurred boundaries everywhere. This became a great stimulation and she has created a number of works on the effects of globalization on our lives.

She was very aware of trying not to repeat the work of others, and particularly that of celebrated contemporaries such as Andreas Gursky and Edward Burtynsky. She determined to create something fresh with her own unique artistic language.

In *Urban Fiction*, Xing's intention was to use 'fiction' to talk about 'reality'. The maquettes she photographed were all made to promote real-estate developments being planned in China. They will become real buildings in the cities sooner or later. By visiting hundreds of showrooms, she became more aware of how an architectural space would affect desires and emotions, and how human dreams are led by commercial promotions. Are people happier after taking possession of a better private space?

The artist states: 'The entire body of work of *Urban Fiction* is playful and fictitious – and somewhere between reality and fantasy. All the figures in this series are acts of my own self, playing different characters. This creates another paradox: I am real, but at the same time I am unreal. The figures act out totally imaginative roles and fanciful stories, staged within the maquettes, their plots invented by me and visualized for these spaces.'

'With the density of a city, people live in cubes, squeezed next to one another, separated only by thin walls. This physical proximity, instead of leading to greater closeness and intimacy between people, can often create psychological distance and loneliness.'

RIGHT
IMAGE 5 (PLUS DETAIL ABOVE RIGHT) (FROM THE SERIES *URBAN FICTION*), C-PRINT

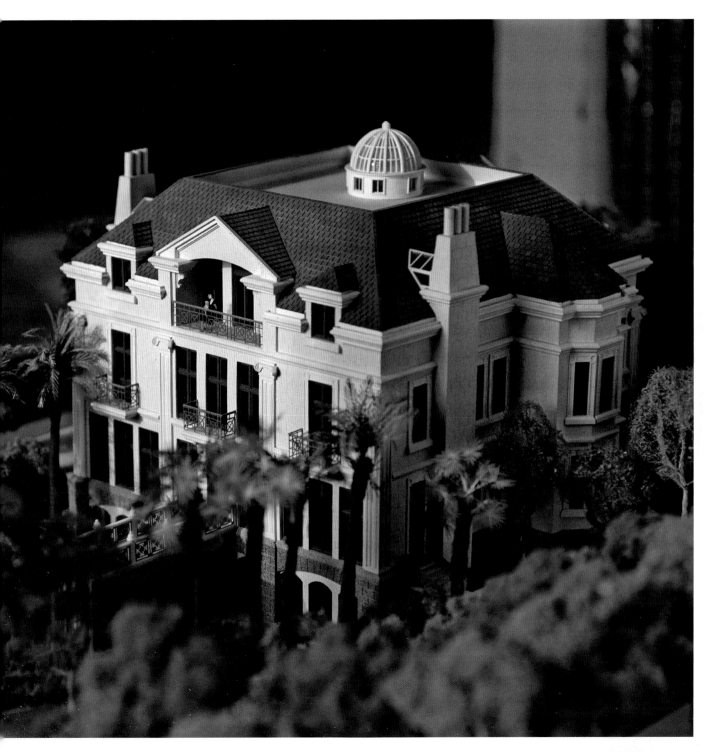

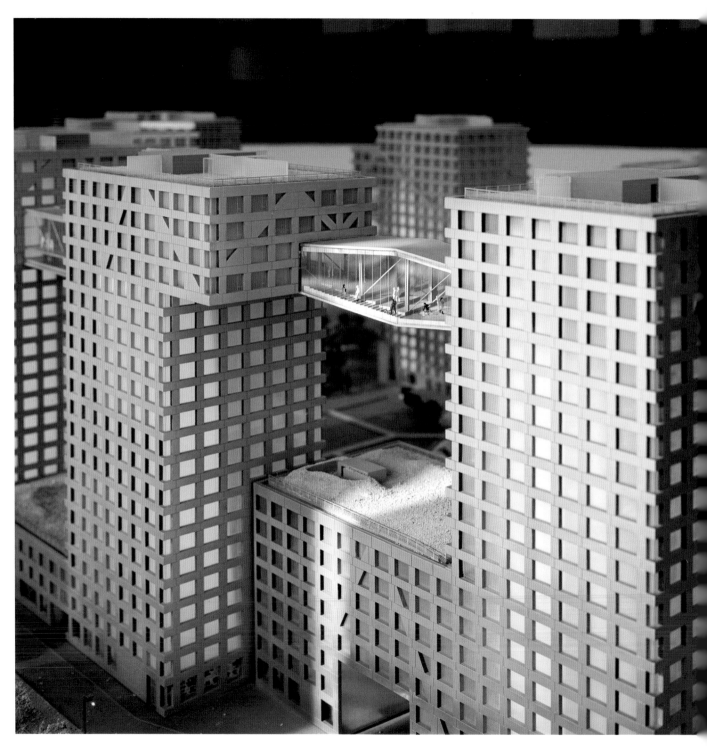

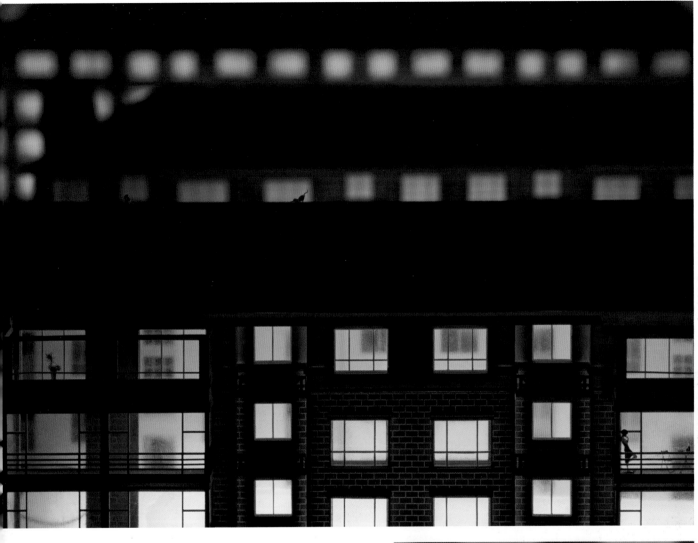

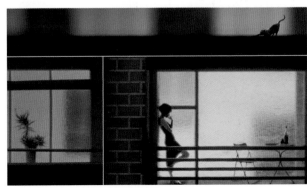

LEFT
IMAGE 12 (DETAIL)
(FROM THE SERIES
URBAN FICTION),
C-PRINT

ABOVE AND RIGHT
IMAGE 24 (DETAILS RIGHT)
(FROM THE SERIES
URBAN FICTION),
C-PRINT

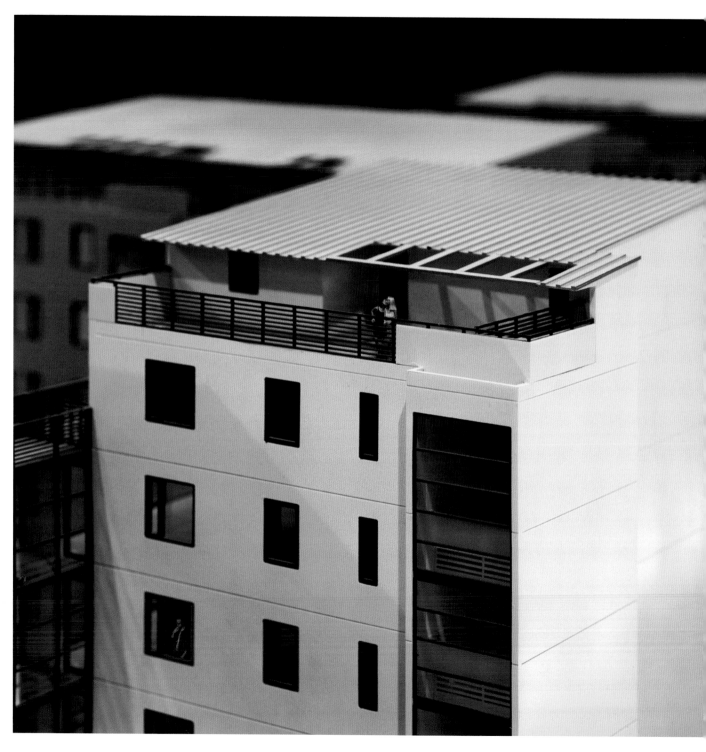

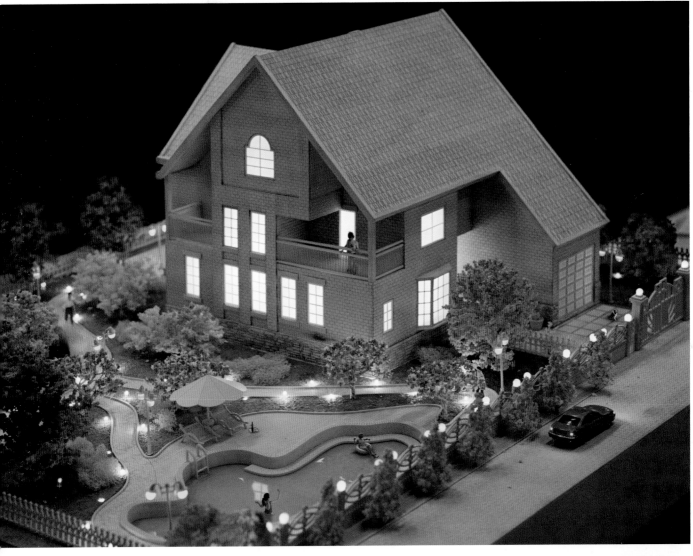

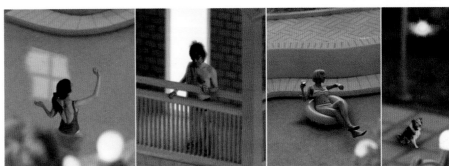

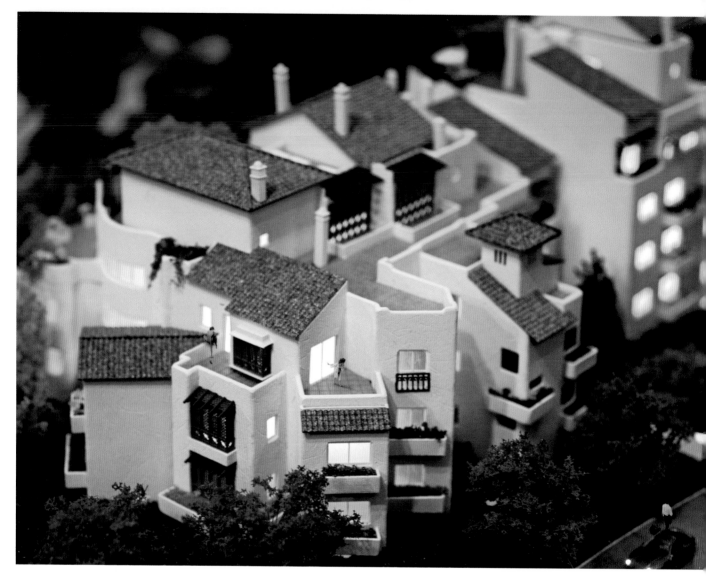

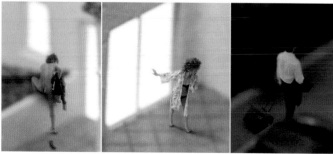

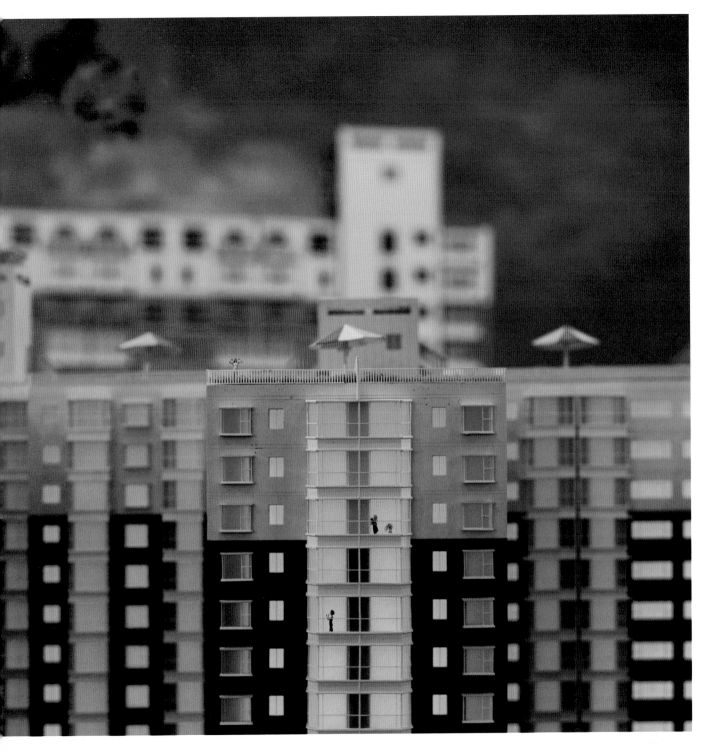

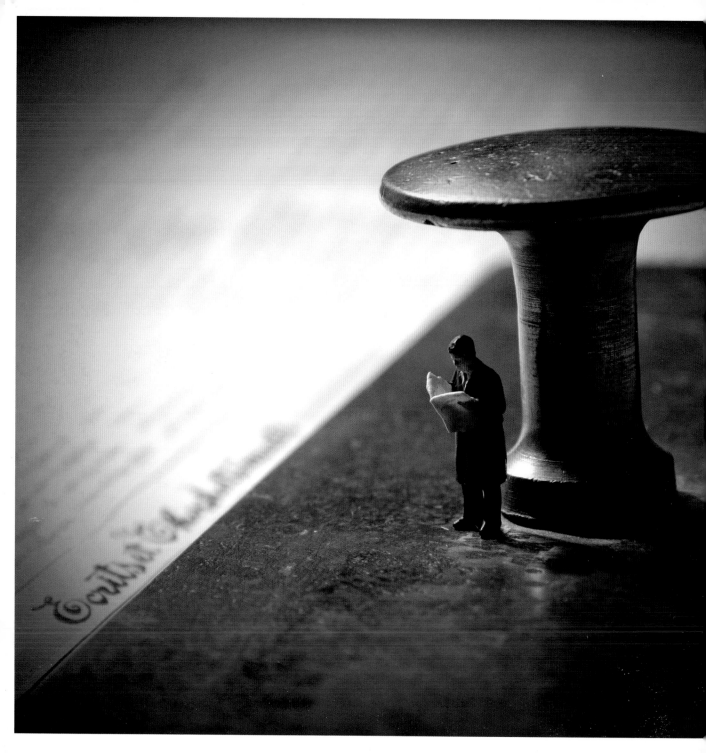